U0076669

Purification

Belief

信仰

潔淨

Blessing

Tr

Commiseration

光耀

Confession

憐憫

Transcendence

喜樂

THE BEAUTY OF NATURE IN RELIGIONS

宗教自然之美

Joy

Blessing

真誠

和諧

世界宗教博物館
MUSEUM OF WORLD RELIGIONS

尊 重 每 一 個 信 仰
Respect For All Faiths

包 容 每 一 個 族 群
Tolerance For All Cultures

博 愛 每 一 個 生 命
Love For All Life

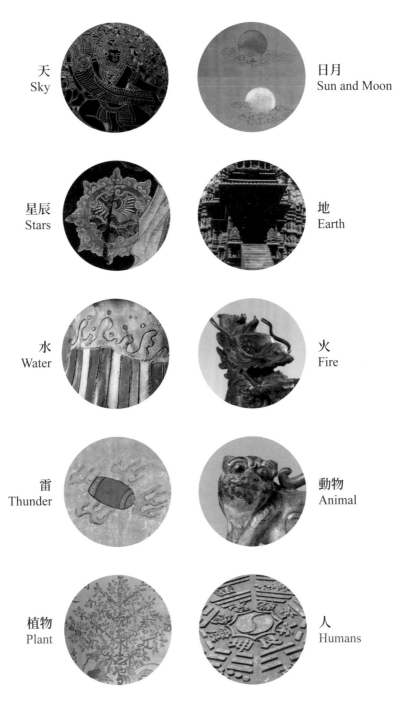

天
Sky

日月
Sun and Moon

星辰
Stars

地
Earth

水
Water

火
Fire

雷
Thunder

動物
Animal

植物
Plant

人
Humans

目錄 Contents

宇宙洪荒 ——世界的誕生
Primordial Universe ── Birth of the World

天 Sky

日月 Sun and Moon

星辰 Stars

厚德載物 ——世界的組成
Virtue Carries All ── The Composition of the World

地 Earth

水 Water

火 Fire

雷 Thunder

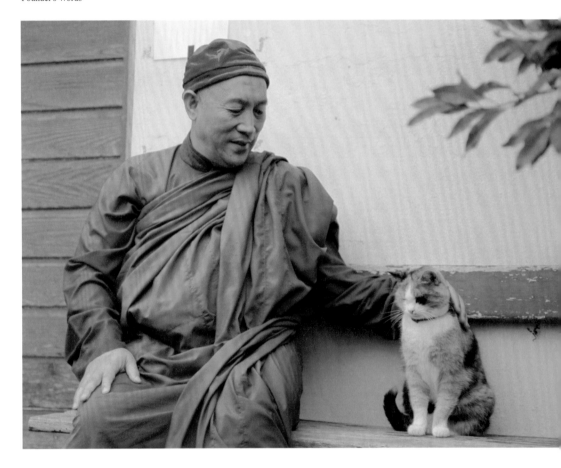

我一直在想，我們能為現在的社會做什麼，一直想為這不完美的世界做點貢獻。

靈性就是生命共同體，我們都在同一個生命共同體裡面，如同我們都愛惜自己的生命，我們也要愛護所有的生命，因為這些生命都是靈性所變，都是靈性的化身。我們必須用這種心態面對生態，萬物跟我們息息相關。地球只有一個，我們必須保護我們共同的家園。

I have always been wondering what we can contribute to the current society, to this imperfect world.

Spirituality is the community of life. We are all involved in the same community. Just as we cherish our own lives, we should cherish all live because they are all transformed from the spirituality. We should treat the environment with this mindset as all living things are closely bound up. We only have one Earth. We must protect our home.

Hsin Tao　Dharma Master
Founder of the Museum of World Religion

前言
Preface

靈性是一種昇華，超越物質世界的範疇，回歸內心來作心靈的自我實踐，也是一種與自然生態和諧共存的關係。當生態環境逐漸被破壞，世界的氣候變得極端，暴雨、乾旱、海平面上升、熱浪來襲。海洋生態系統變得異常、綠地正在逐漸消失，這樣的情況下，我們還剩下什麼？或許天空是我們還沒被奪走的，但是在夜晚，因城市光害，我們也越來越難看到星星，甚至也干擾了生物的作息。這些我們該怎麼解決？當我們意識到照顧地球，就是照顧我們自己，拯救地球，就是拯救我們的內心，覺知被打開後，就會恍然大悟，人類本來就是自然的一部分。

在以往的世界宗教中，並沒有生態永續的觀念，但各自都有對自然的解讀。在佛教的世界中，自然與萬物都是無常的，一切都在不斷的變化。在《華嚴經》中有所謂「因陀羅網」這個意象，形容晶瑩剔透的珠玉，結成一張如宇宙般的大網，每一顆寶石都反射網中其他寶石的影像，相互輝映，來表示世界上所有的事物及一切的價值，都是相互依存、相互影響，這又與生態學的觀點是一致的。而其他的宗教是如何看待自然，又如何與自然相處的呢？面對這龐大的命題，我們透過蒐羅館藏近五千件文物及細節，初窺回應了這個大視角。世界宗教博物館作為以生命教育、宗教包容為要旨的博物館，靈性與文物的結合，「自然」會是個探尋的起點。「百千法門，同歸方寸」，世界上有各種不同的宗教及法門，所以感受、理解世界的方式都不同，但最重要的還是每個人都要回歸內心，藉由與自然重新展開連結，進而關心並付諸行動，全體的生命才能看見希望。

Spirituality, a kind of sublimation, beyond the material world, is a self-practice to return to the heart and a harmony coexistence with the nature. When the natural world is gradually damaged and the world's weather becomes intense and extreme with deluge, droughts, rising sea levels and heatwaves. The marine ecosystems become abnormal and green spaces are gradually taken away. Under the circumstances, what do we have left? The sky may not be taken away from us. However it becomes increasingly difficult to see the stars, and it even disrupts living creatures' lives at night because of urban light pollution. How do we solve these issues? Once we realize that caring for the Earth is caring for ourselves, saving the Earth is saving ourselves, we are awaken, we will realize that humans are inherently part of nature.

In the past the concept of ecological sustainability was not involved in world religions, but each religion had its own interpretation of nature. In the Buddhist world, nature and all things are impermanent and constantly changing. The metaphor of "Indra's Net" in the Avatamsaka Sutra refers to a universe-like net formed by crystal clear jewels. Each jewel reflects the image of the others and shining mutually to represent how all things and all values in the world are interdependent and influencing each other. It is consistent with the viewpoint of ecology. How do other religions view nature, and how do they coexist with nature? Due to the vastness of the topic and limited materials, it will inevitably be insufficiently detailed. As a museum dedicated to life education and religious tolerance, the Museum of World Religions starts to explore the topic with the integration of spirituality and cultural artifacts. "The doors to Goodness, Wisdom and Compassion are opened by keys of the heart." There are various religions in the world, so there are different ways to feel and understand the world. What is most important is that everyone returns to their heart. Through reconnecting with nature, and thereby caring and taking action, all life can see hope.

宇宙洪荒

世界的誕生

脫離混沌掰開天與地，
日月星辰運轉時間之流，
風水光土循環流動，
生生不息，由此展開......

Primordial Universe

Birth of the World

Break away from the chaos, break apart heaven and earth,
Sun, moon, and stars in the flow of time,
Wind, water, light and soil circulate and flow,
The endless life begins...

天
Sky

人類的確已經能夠進入天空，甚至探索外太空。然而，即使在科技高度發達的今天，人類對天空的幻想並未完全消失。科技使我們接近了天空，但宇宙的浩瀚與未知依然激發人類對於探索的想像與夢想。當我們向宇宙發射探測器，或是透過望遠鏡窺視那遙遠的星體時，古老的問題仍然在迴響：我們是否孤獨？宇宙的極限在哪裡？

Human beings are already able to enter the sky and even explore the space. However, even with highly advanced technology nowadays, the human fascination with the sky has not completely disappeared. Technology allows us to approach the sky, but the vastness and unknown of the universe still inspire human imagination and dreams of exploration. When we launch probes into the cosmos or peer at distant planets through telescopes, the ancient question still echoes: Are we alone? Where are the limits of the universe?

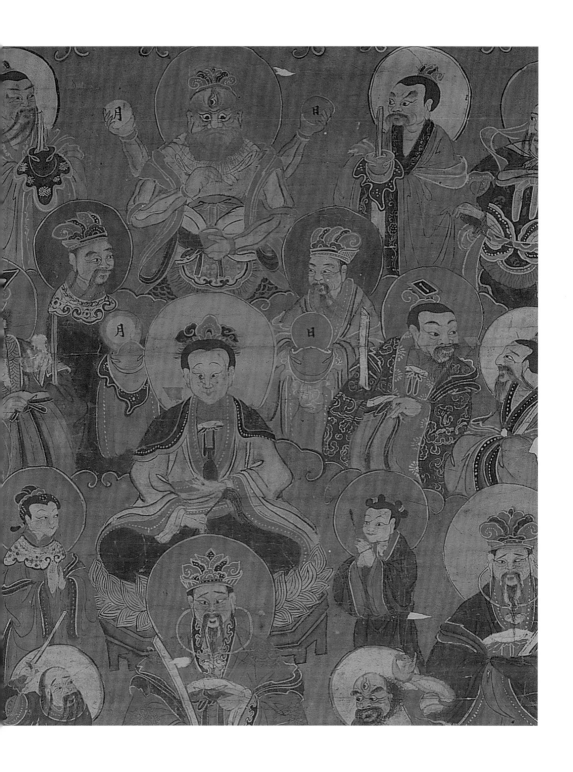

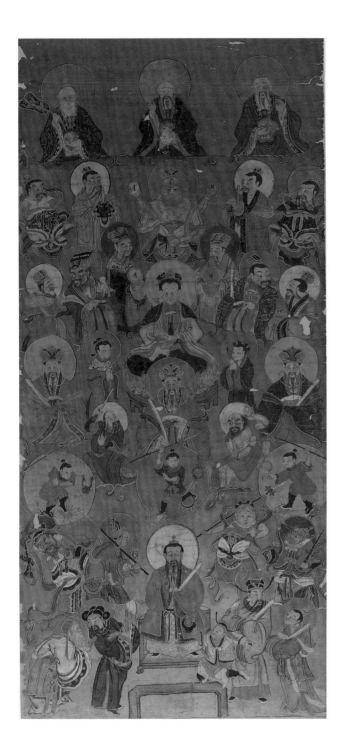

諸神圖

材質：紙
年代：清代
尺寸：67.8 × 148.5 公分

道教流傳於中國西南地區所設的壇場，多在正中高懸一巨幅神圖，稱為「總真圖」，通常用於儀式法場佈置，是道壇至為重要的法物。諸神圖掛軸採由上至下排列方式，三清位居最上端，其下以中尊為主，依次為東王公、西王母、斗姥等，左右分列相關神祇，構成層級分明的神譜圖像，通常用於儀式法場佈置，常見於大陸川、貴地區，在台灣十分少見。

Illustration of the Daoist Pantheon

Material: Paper
Era: Qing Dynasty (1644-1912 CE)
Dimensions: 67.8 × 148.5 cm

The Daoist altars of Southwest China tend to hang a large scroll depicting deities, known as Zongzhentu, in the center. It is typically used in ritual spaces and considered an essential object for the Daoist altars. The Illustration of the Daoist Pantheon is arranged from top to bottom with the Three Pure Ones at the top, followed by central deities such as the King Father of the East, Queen Mother of the West, Doumu Mother of the Great Chariot and other related deities on the sides, and therefore forms a clear hierarchy of divine figures. This arrangement is commonly used in ritual spaces and is prevalent in Sichuan and Guizhou of Mainland China, but rarely seen in Taiwan.

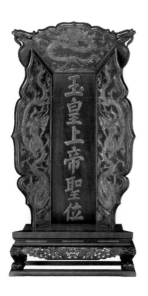

天公牌位

材質：木
年代：西元二十一世紀
尺寸：69×130×27 公分

Jade Emperor Tablet

Material: Wood
Era: 21th century CE
Dimensions:
69×130×27 cm

「天公」，即「玉皇大帝」之俗稱，為民間神系之至高神，源自殷商時期的天神崇拜。早期玉帝並不塑具體的形象，多以天公爐或天公牌位為象徵，表達出敬天信仰之普遍性。後來民間逐漸以人間帝王的形象塑之，而為穿帝袍、戴帝冕之像，多奉於宮廟最高層的天公殿。

Jade Emperor, also known as Heavenly Grandfather, is the supreme deity in the folk pantheon and originates from the deity worship during the Shang . Initially, the Jade Emperor was not depicted with an actual image, but often symbolized by a censer or plaque to represent the universality of the belief in Heaven. Later, the folk gradually present the Jade Emperor in the image of an earthly emperor, wearing imperial robes and a crown. Such images are mostly enshrined in the highest halls of temples dedicated to the Jade Emperor.

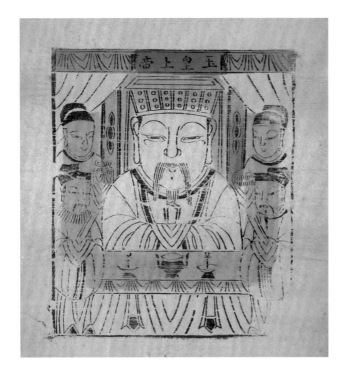

玉皇大帝

材質：紙
年代：清代
尺寸：28×31.5 公分

Jade Emperor

Material: Paper
Era: Qing Dynasty (1644-1912 CE)
Dimensions: 28×31.5 cm

西王母

材質：木
年代：南宋－元代
尺寸：59 × 33.5 × 102.5 公分

或稱金母、王母娘娘，因其居於
崑崙瑤池，故又稱為瑤池金母，
道教將其納入神系，掌管女子登
仙名籍。西王母信仰在中國具有
久遠的歷史，傳說甚多，如《山
海經》中的崑崙山女神；漢代民
間則稱西王母與東王公為分掌陰
陽的尊神等等。日治後，台灣的
王母信仰自東部發跡傳播，造型
多雍容華貴、端莊凝重。

Queen Mother of the West

Material: Wood
Era: Southern Song Dynasty-
Yuan Dynasty (1125-1368 CE)
Dimensions: 59 × 33 × 102.5 cm

Also known as the "Golden Mother" or
"Queen Mother," the Queen Mother of
the West resides in the Jade Pond of
Kunlun and is thus also called the "Jade
Pond Golden Mother." Daoism includes
her into the pantheon for overseeing
the registry of women ascending to
immortality. The belief in the Queen
Mother of the West has a long history
in China with many legends. For
example, the goddess of Mount
Kunlun in the Classic of Mountains
and Seas; Queen Mother of the West
and Dongwanggong, King Father
of the East, are respectively referred
to deities governing Yin and Yang in
the Han dynasty. After the Japanese
occupation, Taiwanese belief in the
Queen Mother starts from the eastern
part of Taiwan and then spreads, and
they often show the Queen Mother in a
graceful, dignified, and solemn figure.

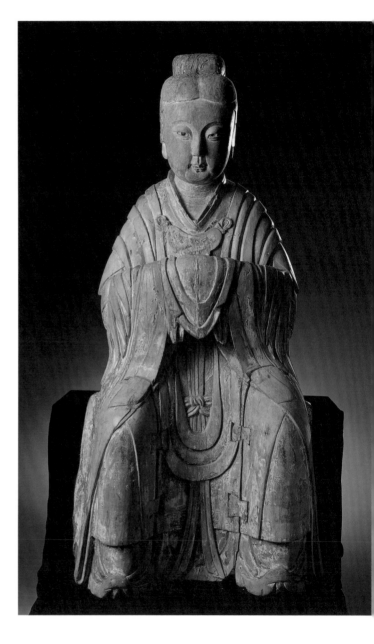

九天玄女

材質：木
年代：待考
尺寸：20.5×39.5×16.8 公分

又稱九天娘娘。原是中國古代神話中的女神。據說奉西王母命傳授黃帝天書與兵法，使其成功大破蚩尤。後為道教所信奉，地位僅次於西王母。而在民間信仰中，九天玄女被奉為打石匠、製香業的行業神。此神像為粉面坐姿，身著蟒袍，右手執一拂塵，左手比劍訣。

Mysterious Woman of the Nine Heavens

Material: Wood
Era: To be determined
Dimensions:
20.5×39.5×16.8 cm

Originally a female deity in ancient Chinese mythology, the Mysterious Woman of the Nine Heavens was said to be commanded by the Queen Mother of the West to instruct the Yellow Emperor in the heavenly scriptures and military tactics and therefore it led to his successful defeat of Chiyou. Later, she was revered in Daoism, second only to the Queen Mother of the West. In folk belief, the Mysterious Lady of the Nine Heavens is venerated as the patron deity of stonemasons and the incense-making industry. This figure shows her with a powdered face in a seated position, wearing a python robe, holding a horsetail whisk in her right hand, and making a sword gesture with her left hand.

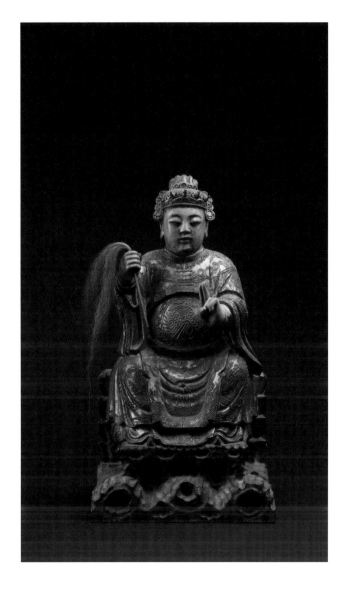

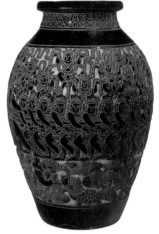

▲ 乳海攪拌圖瓶正面　　　　　　　▲ 乳海攪拌圖瓶反面

乳海攪拌圖瓶

材質：陶
年代：待考
尺寸：35×55×35 公分

印度教眾神為解生老病死之困擾，善神（提婆）惡神（阿修羅）們共謀攪拌乳海以取得其中長生不老的甘露，其中毗濕奴化身巨龜沉入海底，作為攪杵的支點，並以龍王婆蘇吉的身體為纏繞在曼達羅山上攪杵的攪繩。九十二個阿修羅持蛇頭，八十八個提婆持蛇尾，以輪流撥動巨蛇身體的方式，一起攪拌乳海。歷經難關終得甘露，卻因阿修羅意圖獨佔，引發新的混亂，最終甘露回到提婆們的手上，逐一服用，其中阿修羅「天光」混入隊伍中喝甘露，被日神與月神告發，因而使阿修羅「天光」失去身體。「天光」為了報復，追著日神與月神，一旦追上將二神吞入口中，因而造成日蝕與月蝕。而當日月自其喉嚨而出，蝕也結束了。

Vessel with illustration of Samudra Manthana

Material: Pottery
Era: To be determined
Dimensions: 35×55×35 cm

In Hindu mythology, to solve the troubles of life, death, and rebirth, the gods (devas) and demons (asuras) conspired to churn the Ocean of Milk to obtain the elixir of immortality. Vishnu transformed into a giant turtle and submerged to the ocean to serve as the pivot for the churning rod and wrapped the body of Vasuki, a naga, around Mount Mandara as the churning rope. Ninety-two asuras held the serpent's head, and eighty-eight devas held serpent's tail to jointly churn the Ocean of Milk in turns. After overcoming many obstacles, they finally obtained the elixir. However, the asuras intended to monopolize it, and therefore it led to new chaos. In the end, the elixir returned to the devas, and they consumed it one by one. Among the asuras, Svarbhānu disguised himself and drank the elixir, but was exposed by the deities of the sun and the moon. It resulted in his beheading. To seek revenge, he chases the deities of the sun and the moon and causes the eclipses whenever he catches and swallows them. When they emerge from his throat, the eclipse ends.

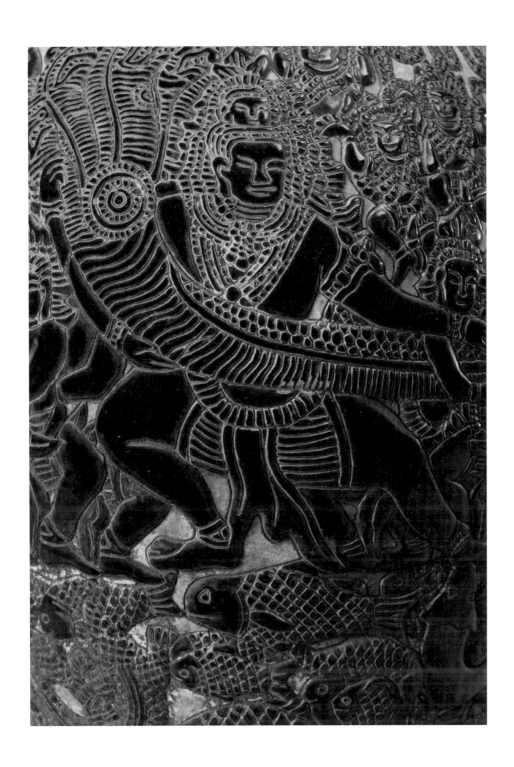

日月
Sun and Moon

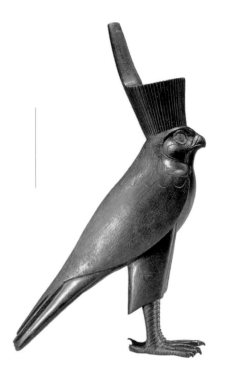

太陽被視為生命之源和光明的化身,是許多古代文化中的
主要神祇之一。在古埃及,太陽神拉是最重要的神之一,
象徵光明、創造和秩序。而月亮則常與女性、生育和再生
等概念相關聯。月亮神往往是女性,月亮的周期也與潮汐
相關聯。日月象徵了白晝和黑夜的對立,同時代表著人體
生理節奏與自然之間的緊密關聯。

The sun is seen as the origin of life and the embodiment of light and is one
of the main deities in many ancient cultures. In ancient Egypt, the sun god
Ra, one of the most important gods, symbolizes light, creation, and order.
The moon is often associated with concepts such as femininity, fertility,
and regeneration. Moon deities are often female, and the moon's cycle is
also linked to the tides. The sun and moon symbolize the opposition of
day and night and also represent the close connection between the human
physiological rhythm and nature.

賀魯斯

材質:青銅
年代:古埃及後期(664-332 BCE)
尺寸:12.5×20.8×5.8 公分

鷹隼形象的賀魯斯是古埃及信仰
中的太陽神之一,代表日正當中
的太陽,也是法老王權的象徵。
祂頭戴統一埃及的雙重王冠,而
右眼代表太陽,象徵健康與光
明;左眼則象徵月亮,與治癒和
再生緊密相連。這雕像常於賀魯
斯神廟作獻祭之用,彰顯祂作為
天空之神的守護者角色。

賀魯斯之眼

材質：花崗石
年代：第二十一王朝（Ca. 1070-946 BCE）
尺寸：2.3×3.2×0.5 公分

賀魯斯之眼，是古埃及最著名的護身符，象徵保護與再生。傳說中，賀魯斯在與邪神賽特戰鬥中失去一眼，後被智慧之神托特用自然力量治癒，賦予其超自然的保護力。埃及人將其用於墓室和日常飾品，以保護靈魂，並象徵對自然的尊重與理解。

Horus

Material: Bronze
Era: ca. 664-332 BCE
Dimensions: 12.5×20.8×5.8 cm

Eye of Horus

Material: Granite
Era: ca. 1070-946 BCE
Dimensions: 2.3×3.2×0.5 cm

The falcon-headed Horus is one of the sun gods in ancient Egyptian belief. He represents the sun at its zenith and symbolizes the power of pharaoh. He wears the double crown of united Egypt. His right eye represents the sun and symbolized health and light. His left eye symbolizes the moon, closely associated with healing and rebirth. This statue is often used for offerings in the temples of Horus and highlights his role as the guardian of the sky.

The Eye of Horus is one of the most famous amulets in ancient Egypt and symbolizes protection and rebirth. According to the legend, Horus lost an eye in battle with the evil god Seth, and was later healed by Thoth, the god of wisdom, with natural forces, which endowed it with supernatural protective power. Egyptians used it in tombs and everyday ornaments to protect the soul and show their respect and understanding of nature.

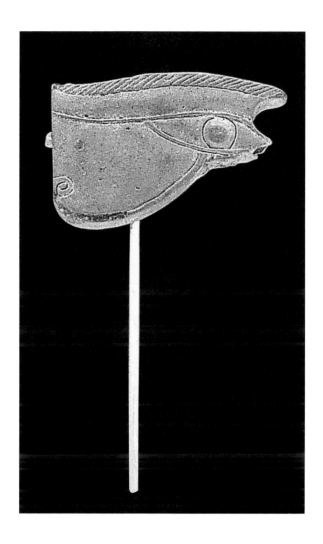

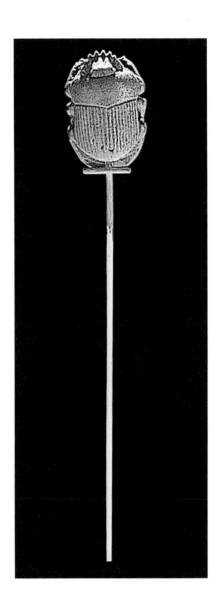

埃及聖甲蟲

材質：塊滑石
年代：新王國時期 Ca. 1150-1070 BCE
尺寸：1.5×2.1×1 公分

古埃及將推糞金龜稱作「聖甲蟲」，把其視為太陽神「凱布利」的象徵。聖甲蟲滾動球形物體的行為，被比喻為傍晚西沉的落日，以朝陽之姿東升。代表了自然界中的永生與重生。聖甲蟲雕刻的物品，常見於陵墓和神廟中，用以保護和引導亡靈在來世重獲新生。

Scarab

Material: Steatite
Era: New Kingdom, ca. 1150-1070 BCE
Dimensions: 1.5×2.1×1 cm

In ancient Egypt, the dung beetle was called the "scarab" and symbolized the sun god "Khepri." The behavior of the scarab rolling spherical objects was likened to the sun setting in the west in the evening and rising in the east in the morning. It represents eternal life and rebirth in nature. Scarab-shaped objects are commonly seen in tombs and temples and were used to protect and guide the soul to rebirth in the afterlife.

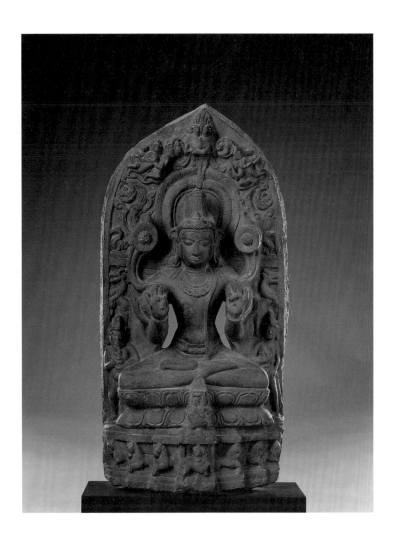

日神舍雅

材質：黑頁岩
年代：西元十一世紀
尺寸：44.5×78×19 cm

Surya (Sun Deity)

Material: Black schist
Era: 11th century CE
Dimensions: 44.5×78×19 cm

印度教的日神有多位，吠陀時期即有關日神舍雅的記載。日神雙手各持一朵蓮花，結全跏趺坐於蓮花座上。蓮花座前為日神的馬夫駕馭七匹馬，兩旁的為其侍從，他們的頭上各有一隻猛獸象徵日神舍雅是宇宙性的；日神的頭上有兩個飛天，飛天的身後各有一個體型較小的侍者。

There are many Sun gods in Hinduism, with records of Surya dating back to the Vedic period. Surya holds a lotus in each hand, seated in full lotus position on a lotus throne. In front of the throne, Surya's charioteer drives seven horses and is flanked by attendants with a fierce animal adorned above their head, symbolizing Surya's cosmic nature. Above Surya's head are two flying apsaras, each followed by a smaller attendant.

太陽星君、太陰星君

材質：木
年代：待考
尺寸：20.2×44×17.5 公分；
19.7×42×17.2 公分

太陽星君或稱「太陽帝君」，即
太陽神。早在遠古時期，帝堯定
有春分朝日、秋分踐日的祭祀傳
統，歷代各朝均有崇奉，民間亦
然。在台灣民間奉祀者不多，常
與太陰星君一起奉祀，亦有專
祀。

太陽星君造像通常為人類形象，
擁有紅面、紅鬍鬚，手持代表太
陽之令牌。在民間因太陽星君象
徵光芒普照，代表公正、博愛的
精神，因此廣受法律工作者、社
會工作者所尊崇。

太陰星君又稱「太陰娘娘」，即
月神，如同祭日般，在遠古時期
便有祭祀月神的傳統。民間亦將
太陰娘娘視為嫦娥，附會許多與
月亮相關的神話傳說。

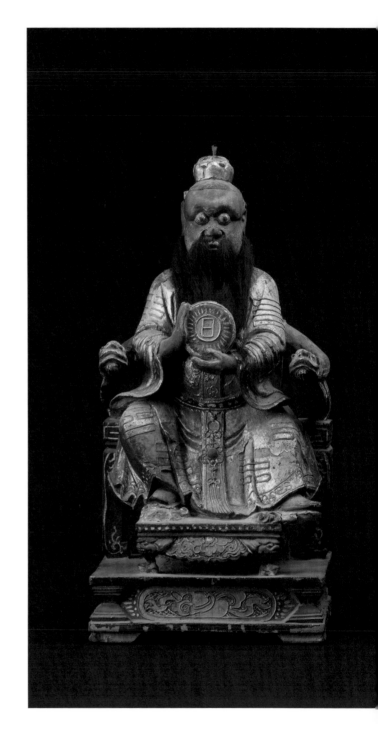

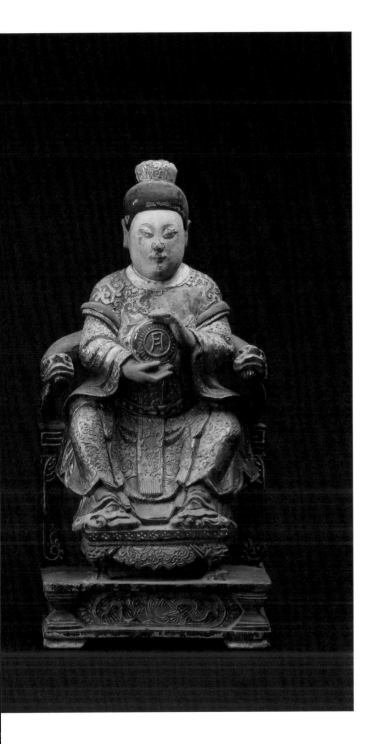

Sun Lord,
Moon Lady

Material: Wood
Era: To be determined
Dimensions: 20.2 × 44 × 17.5 cm;
19.7 × 42 × 17.2 cm

Sun Lord , also known as Sun Emperor , represents the solar deity. In the ancient times, Emperor Yao set up the tradition of worshipping the sun during the vernal equinox and the autumnal equinox and the tradition has been revered throughout various dynasties and by the common people. In Taiwan, there are not many who worship the Sun Lord, and he is often worshiped together with the Moon Lady although there are still temples dedicated solely to the Sun Lord. The image of the Sun Star Lord is usually in human form with a red face and red beard as well as holding a tablet with incantation representing the sun. In folk belief, the Sun Lord symbolizes the sun shines on all, represents the spirit of justice and universal love and thus is revered by legal workers and social workers. Moon Lady, also known as Moon Empress , is the lunar deity. Just as there are rituals to worship the sun, there has been a tradition of worshipping the moon since ancient times. Folk traditions also regard the Moon Lady as Chang'e and associate her with many myths and legends related to the moon.

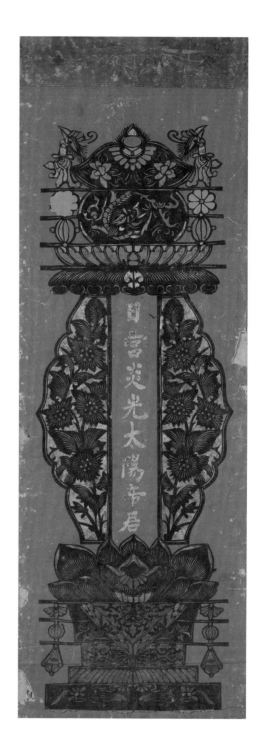

太陽星君、太陰星君神牌

材質：紙

年代：明代

尺寸：22.2×66.9×0.1 公分；
22×66.4×0.1 公分

此二件為道壇科儀桌上使用的神
牌，以黑色剪紙剪出神牌的樣
式，並用剪鏤方式以金、銀箔紙
襯底，製造鏤刻的視覺效果，再
以神牌座的輪廓圖樣貼於紅底紙
之上。神牌名諱則以金漆將八字
用楷體書於其上，神牌上方有四
爪金龍作飾，兩旁有植物花紋，
下方則是蓮花檯座。

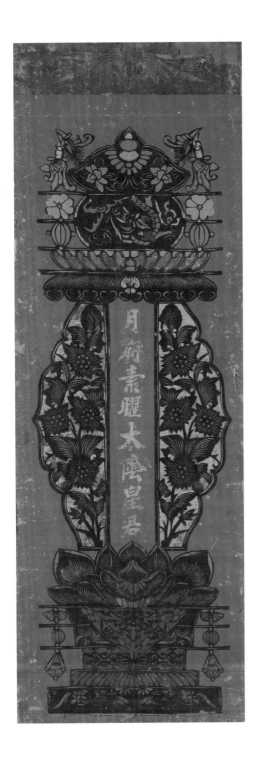

Spirit Tablets of Sun Lord and Moon Lady

Material: Paper
Era: Ming Dynasty (1368-1644 CE)
Dimensions: 22.2×66.9×0.1 cm;
22×66.4×0.1 cm

These two objects are spirit tablets used on the ritual table of Daoist ceremonies. They are cut out in black paper in the shape of spirit tablets with gold and silver foil paper as the background to create a carved visual effect, and then pasted on red paper with the outline of the spirit tablet stand. The names of the deities are written in gold lacquer in regular script on the tablets. The tablets are adorned with four-clawed golden dragons on the top and on the plant-derived patterns on the sides. The stand is decorated with lotus flowers.

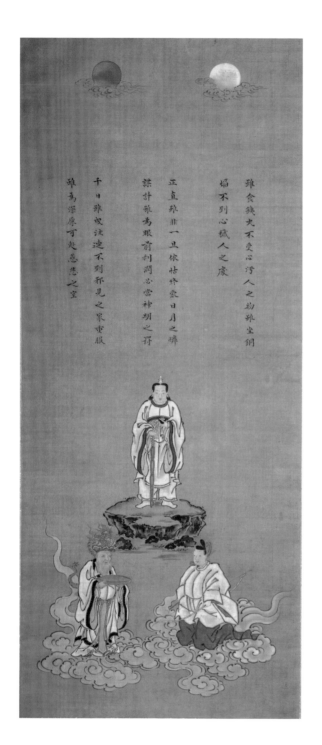

雖爲源可救慈悲之室

千日雖受法違不到邪見之眾甫服

謀計雖爲眼前利潤心當神明之詐

正直雖非一旦依怙終蒙日月之憐

媚不到心識人之處

雖食錢丸不變心污人之物非塵鍋

三社託宣圖

材質：絹本著色
年代：西元十九世紀早期
尺寸：163.8×53.5 公分

三社託宣圖描繪日本三大神社的主神。中央的天照大神是太陽女神，象徵光明與生命力；左側的春日明神象徵自然與生長，與動物和狩獵關聯密切；右側的八幡神則代表戰爭與和平。畫作上方神諭提醒人們在困難時仍應保持正直與道德，思考行動對自然和宇宙秩序的影響，強調了天照大神所代表的「正直」精神。

Three Great Oracular Deities

Material: Ink and color on silk
Era: Early 19th CE
Dimensions: 163.8×53.5 cm

The Three Great Oracular Deities depicts the principal deities of Japan's three major shrines. In the center is Amaterasu Omikami, the goddess of the sun, symbolizing light and vitality; to the left is Kasuga Myojin, representing nature and growth and closely associated with animals and hunting; to the right is Hachiman, representing war and peace. The oracle above the painting reminds people to keep integrity and morality during difficult times, and to think about the impact of their actions on nature and the order of the universe. It also emphasizes the spirit of "righteousness" represented by Amaterasu.

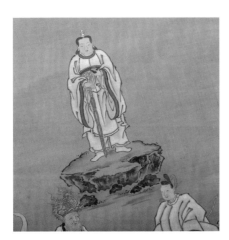

光與宗教建築

伊勢神宮的正式名稱為「神宮」，位於日本三重縣伊勢市，由供奉天照大御神的皇大神宮（內宮）以及供奉豊受大御神的豊受大神宮（外宮）為主的125座神社所構成。伊勢神宮的主要建築物朝向東方，這意味著神社可以在每天的清晨第一線陽光照射進來。這不僅象徵著太陽女神的光明與清晰，也使得整個空間在日出時分被神聖的光芒所覆蓋。

Light and Religious Architecture

Ise Jingu (Grand Shrine of Ise), officially "Jingu," is located in Ise City, Mie Prefecture, Japan. It consists of 125 shrines primarily dedicated to Amaterasu- Omikami at the Inner Shrine (NaikO) and Toyouke-Omikami at the Outer Shrine (GekO). The main buildings of Ise Jingu face east, meaning the shrine receives the first rays of sunlight each morning. This not only symbolizes the brightness and clarity of the sun goddess but also allows the entire space to be covered with sacred light at sunrise.

星辰
Stars

星星不僅是夜空的裝飾，更是感知時間、方向和宗教儀式的重要元素。在許多文化中，星星被認為是神或祖先的化身。北極星因其在天空中的固定位置被視為不朽和永恆的象徵，同時也是心靈上的慰藉和指引。夜空的浩瀚給遠古人類帶來了對於宇宙更大秩序的思考，以及個人和集體命運的沉思。

Stars are not merely ornaments of the night sky but also essential elements for perceiving time and direction as well as performing religious rituals. Many cultures consider stars the embodiment of gods or ancestors. The North Star is seen as the symbol of immortality and eternity, as well as a comfort and guide for the soul due to its fixed position in the sky. The vastness of the night sky has brought ancient humans contemplation of a greater cosmic order and reflections on individual and collective destinies.

玄天上帝像

材質：木
年代：日治時期
尺寸：25.2 × 41.1 × 21.7 公分

或稱「上帝公」、「真武大帝」，玄天上帝源自星辰信仰，為北方七宿中的玄武。是為統理北方之道教大神，北方在五行之中屬水，故能統領所有水族與水上事物，也為海神。此尊玄天上帝像戴冠而戎裝，細眉鳳眼，面蓄鬚髯，整體呈現威武的神態，右手原先應有持劍，現已遺失，左手則比劍訣，並有跣足腳踏龜蛇的形象。

Statue of Supreme Emperor of the Dark Heaven

Material: Wood
Era: Japanese colonial period (1895-1945 CE)
Dimensions: 25.2 × 41.1 × 21.7 cm

Also known as "God of Heaven" or "Zhenwu Dadi" (True Martial Great Emperor), Supreme Emperor of the Dark Heaven originates from the worship of stars and represents Xuanwu of the northern constellations. As the Daoist deity governing the North, he is associated with water of the Five Elements. Therefore, he commands all aquatic creatures and water-related matters and is also revered as a sea god. The statue is crowned and armored with fine eyebrows, phoenix eyes, and a bearded face. He exudes a majestic demeanor. His right hand originally held a sword, now lost, and his left hand makes a sword gesture. He stands on a turtle and snake with bare feet.

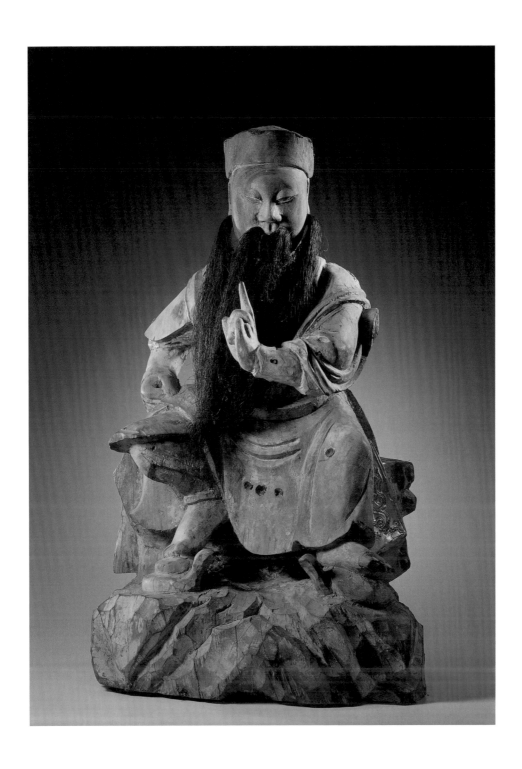

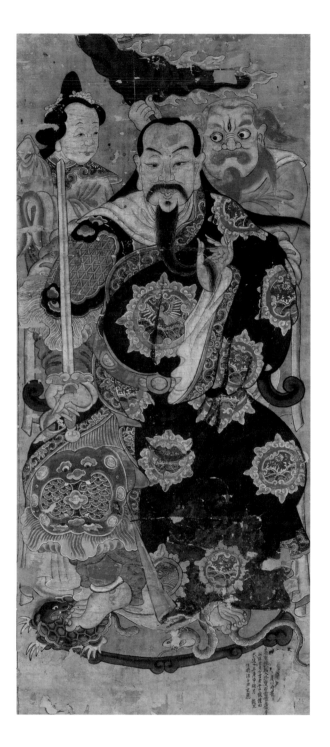

玄天上帝畫

材質：紙
年代：西元1860年
尺寸：66.5×148 公分

本幅為玄天上帝圖，為道教壇場中懸掛的神像畫軸。圖中央的玄天上帝呈坐姿，披髮跣足，全身內穿獸鎧武甲，外披飛禽文袍；右手握無鞘七星劍，左手捧鬚；右足踏龜，左足踩蛇。由題簽內容來看，本畫的年代「天運十年」應為咸豐十年（西元1860年）歲次庚申，供奉於壇中以祈求保佑。

Scroll of Supreme Emperor of the Dark Heaven

Material: Paper
Era: 1860 CE
Dimensions: 66.5×148 cm

The scroll depicts the Supreme Emperor of the Dark Heaven and is hung in Daoist altars. The central figure is seated Supreme Emperor of the Dark Heaven wearing beast armor under a robe adorned with bird patterns barefoot. His right hand holds a sheathless Seven-Star Sword, and his left hand holds his beard. His right foot steps on a turtle, and his left foot steps on a snake. The inscription writes that the scroll was offered in the altar for blessings in the 10th year of Tianyun, corresponding to the 10th year of Xianfeng reign (1860)

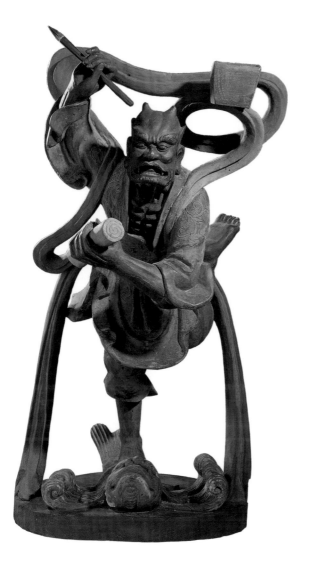

魁星踢斗

材質：木雕上彩
年代：西元十九至二十世紀
尺寸：36×72.8×40.1 公分

魁星又稱魁星爺、大魁夫子或大
魁星帝。源自對北斗七星的星宿
信仰，為西方七宿之第一宿，是
文章科考之神。右手持筆，左手
持書卷，右足踩鰲頭，左腳後揚
踢魁斗，全體造型仿魁字構成，
極具生動感及民間藝術趣味。讀
書人常供奉於書房內，以祈求金
榜題名，榮耀家門。

Kuixing Kicking the Dipper

Material: Painted wood
Era: 19th to 20th century CE
Dimensions: 36×72.8×40.1 cm

Kuixing, also known as Lord Kuixing,
Great Kui Master, or Great Kui Star
Emperor, originates from the worship
of the Big Dipper's stars. Kuixing is
the head of the seven xiu mansions
of the west and the deity of imperial
examinations. His right hand holds
a brush and his left hand holds a
scroll. His right foot is on the head of a
turtle, and his left foot kicks back. The
entire figure is vividly shaped like the
character Kui, full of dynamism and folk
art charm. The literati often worshipped
him in their studios to pray for success
in examinations and glory for their
families.

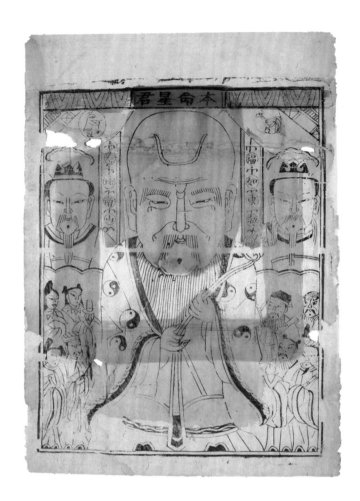

本命星君

材質：紙
年代：清代
尺寸：28×38.5 公分

本命星君為星宿神明，屬自然神崇拜。古代以天干地支記年，每年都各有執掌人間禍福的歲神，為免與人的生辰歲時沖剋，因此祭拜本命星君，乃成為庇祐個人年歲平安，健康如意的方式之一。此幅神禡龕額題有「本命星君」字樣，畫中人物手持如意，衣著八卦之圖樣，左右共祀神八位，後方則有象徵日及月之神。畫上兩側文字為：「福如東海，壽比南山。」

Personal Lord

Material: Paper
Era: Qing Dynasty (1644-1912 CE)
Dimensions: 28×38.5 cm

The Personal Lord is the deity of the constellation related to the nature worship. In ancient times, years were recorded with the Heavenly Stems and Earthly Branches. Each year had its own deity in charge of human fortune and misfortune. To avoid conflicts with one's birth year and time, people worship the Personal Lord to ensure their safety and well-being throughout the year.

This Shenma deity print reads "ben ming xing jun" and presents a central figure holding a ruyi scepter, dressed in a pattern of the Eight Trigrams, and flanked by eight deities, with two deities representing the sun and moon in the background. The texts on both sides of the print reads, "Blessings as vast as the East Sea and lifespan as enduring as the Southern Mountain."

青龍之神

材質：紙
年代：清代
尺寸：**27.3**×**31.6** 公分

白虎之神

材質：紙
年代：清代
尺寸：**26.8**×**40.3** 公分

青龍神與白虎神是從星宿信仰而來，屬天上四方星宿「四靈」。分別為東方青龍，西方白虎，南方朱雀與北方玄武，其在道教中為護法保衛之官將神，常見於進入宮觀前的入口山門處，與眾靈官同祀，而既然為道教護衛官將，自然是以戎裝扮相。此類型印版神像稱為「神禡」或稱「紙馬」，民間以其為神靈化身而加以祭祀，用於供奉、張貼、懸掛或焚燒，整體風格純樸自然，構圖豐富均衡，呈現地方性特色。

Deity of Azure Dragon

Material: Paper
Era: Qing Dynasty (1644-1912 CE)
Dimensions: 27.3×**31.6 cm**

Deity of White Tiger

Material: Paper
Era: Qing Dynasty (1644-1912 CE)
Dimensions: 26.8×**40.3 cm**

The Azure Dragon Deity and White Tiger Deity originate from the belief in celestial constellations. They belong to the "Four Spirits" including the Azure Dragon of the East, the White Tiger of the West, the Vermilion Bird of the South and the Black Tortoise of the North. In Daoism, they are the guardian generals, commonly seen at the entrance of temples and worshipped alongside other divine officials. Since they are Daoist guardians, they are dressed in military attire. These printed divine images, known as "shenma" or "Paper Horses," are venerated as incarnations of the gods, and used for offerings, posting, hanging, or burning. The displays present a simple and natural style, balanced composition, and regional features.

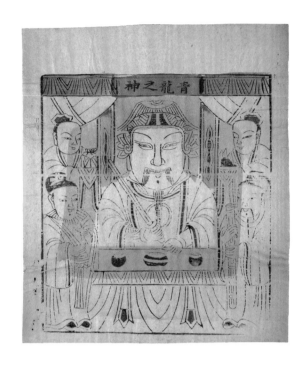

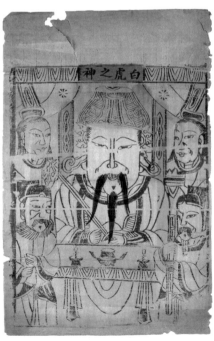

四靈—青龍、朱雀掛軸

材質：紙
年代：待考
尺寸：**34.5×77.8** 公分

四靈—白虎、玄武掛軸

材質：紙
年代：待考
尺寸：**34.1×80.3** 公分

四靈，又稱四象，指的是天上四方星宿所
組成的圖象，即東方的青龍，西方的白
虎，南方的朱雀和北方的玄武。二十八
宿，是中國古代天文學家在觀測天象時，
對日月運行經過的區域的恒星劃分、選定
並標誌的二十八個星群座。四靈即在道士
行法時護衛神靈。其中玄武星神自明代以
後，倍受尊崇而另稱玄天上帝。道教宮觀
常在山門靈官殿兩側，奉祀四靈作為道門
護衛，四靈全身戎裝，神將裝束，間或搭
配青龍、白虎、朱雀、玄武之動物形象。
道教的大型齋醮禮儀中，也多設有四靈
二十八宿的神位，並在科儀中經常有召請
四靈護法的儀式。

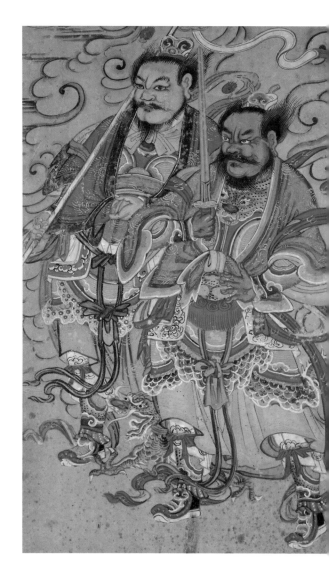

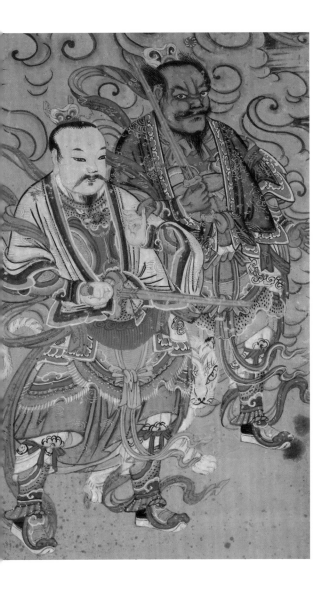

Hanging Scroll of Four Holy Beasts—Azure Dragon and Vermilion Bird

Material: Paper
Era: To be determined
Dimensions: 34.1 × 77.8 cm

Hanging Scroll of Four Holy Beasts—White Tiger and Black Tortoise

Material: Paper
Era: To be determined
Dimensions: 34.5 × 80.3 cm

Also known as "Four Symbols", the Four Holy Beasts refer to the images composed of the stars from four cardinal directions in Chinese celestial constellation, namely Azure Dragon of the East, White Tiger of the West, Vermilion Bird of the South and the Black Tortoise of the North. The Twenty-Eight Mansions are a group of twenty-eight constellations that ancient Chinese astronomers made to mark the movements of the Moon and the Sun across the sky. The Four Holy Beasts are the guardians of Daoist priests during rituals. Among these, the Xuanwu, or the Black Tortoise of the North, has been especially revered since the Ming Dynasty. Xuanwu is also known as the Supreme Emperor of the Dark Heaven In Daoist temples, the Four Symbols are often enshrined on both sides of the main gate in the Lingguan Hall, and serve as guardians of the Daoist gates. They are fully armed and in divine general attire. Sometimes they are adorned with the animal images of the Azure Dragon, White Tiger, Vermilion Bird, and Black Tortoise. In large-scale Daoist fasting rituals, the spirit tablets of the Four Holy Beasts and the Twenty-Eight Mansions are also set up with ceremonies often involving the invocation of the Four Symbols for protection.

厚德載物

世界的組成

大地承載滋養著萬物,
鳥獸草木在地、水、火、雷的循環中,
恣意勃發,活躍繽紛,
是人們崇敬的自然大能。

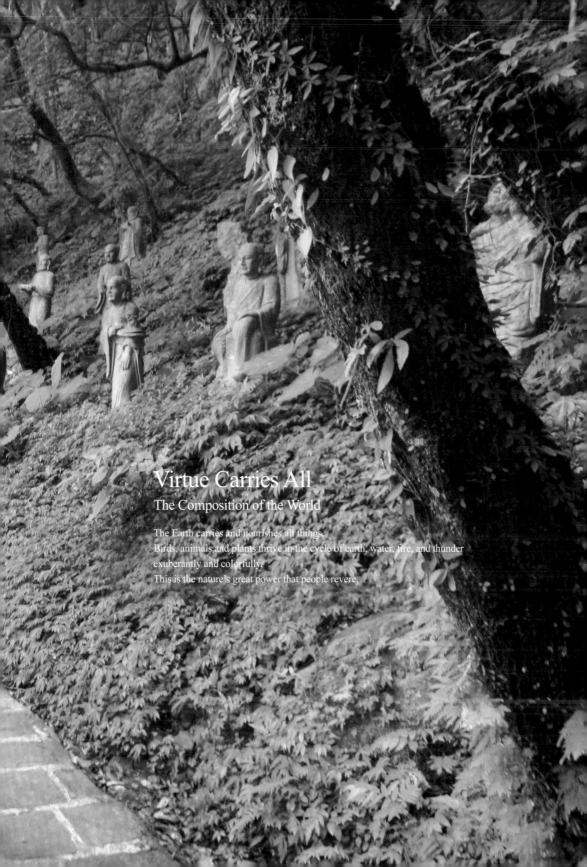

Virtue Carries All

The Composition of the World

The Earth carries and nourishes all things.
Birds, animals and plants thrive in the cycle of earth, water, fire, and thunder
exuberantly and colorfully.
This is the nature's great power that people revere.

地

Earth

土壤是生命的基礎，承載著無限的希望。提供萬物生機，建構豐富的生態系統。四季變遷，生命消長，土地依舊存在，是生命循環的堅韌，是永恆的支柱。

Soil, the foundation of life, carries infinite hope. It sustains all live beings and establishes diverse ecosystems. When the seasons change and lives wax and wane, the land remains like the tenacity of the life cycle and the eternal pillar.

土地公與土地公廟

材質：砂岩
年代：待考
**尺寸：16.5×20×12.7 公分；
101×77×137.5 公分**

本文物一組共兩件，包含土地公及土地公廟。土地公古稱后土、社神，是自然崇拜中與人們最親近的神祇，主宰著無際的大地，農作物的豐收及墓地的守護都與之有關，後來更拓廣到庇佑財帛，民間尊稱其為「福德正神」。 此廟全由石板建造而成，屋脊做燕尾，屋頂為兩片石板，三面壁。刻題廟名「福神宮」。門柱上有對聯：「福澤通宵方方吉慶，神光番社處處興隆。」

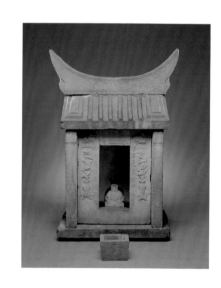

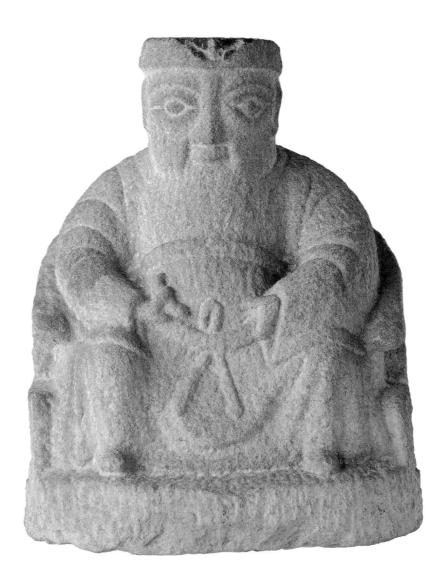

Earth God and Temple

Material: Sandstone
Era: To be determined
Dimensions:
16.5 × 20 × 12.7 cm;
101 × 77 × 137.5 cm

This set includes two pieces, the Earth God and his temple. The Earth God also known as Houtu or Sheshen in ancient times, is the deity closest to the people in nature worship. He governs the boundless land, the harvest of crops as well as the protection of graveyards, and later extends to the protection of wealth. The people respectfully address him as the "God of Fortune and Virtue". This temple is entirely constructed of stone slabs, with swallowtail ridges, two stone slabs for the roof, and three-sided walls. The temple is inscribed with "fu shen gong." The couplets on the doorposts read, "Fortune fills the night with auspicious celebrations; divine light spreads prosperity everywhere."

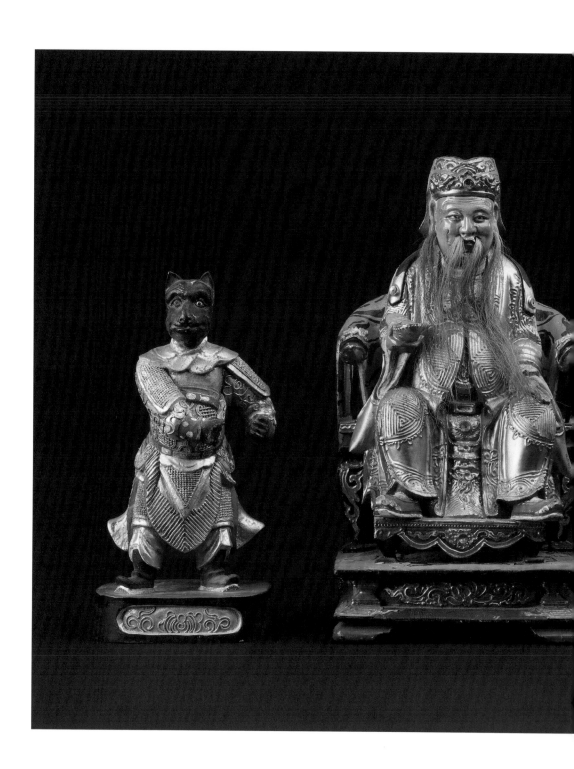

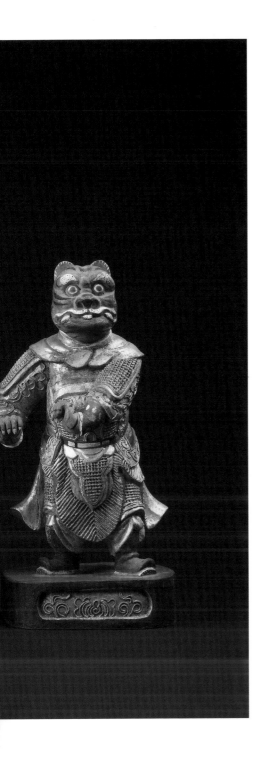

土地公、虎將軍、狗將軍

材質：木
年代：待考
尺寸：**14✕23✕13 公分；10✕20✕9 公分；
10.9✕20.5✕9 公分**

此土地公的造像為台灣民間供奉中常見的造型。頭戴員外帽，右手持元寶，左手置於膝上，面容紅潤蓄有長鬚，衣袍上布滿壽字紋，腳下為紅色步履，座椅為龍頭圈足椅，背面並有虎紋。而虎將軍、狗將軍，作為部將陪祀在兩旁，形貌認真，並身穿金甲。呈現威武的姿態。

Earth God, Tiger General, Dog General

Material: Wood
Era: To be determined
Dimensions: 14✕23✕13 cm; 10.9✕20.5✕9 cm

This exhibit presents a common image of the folk deity in Taiwan. The statue shows the Earth God wearing an official's headwear, holding a gold ingot in his right hand, and sitting with the left hand on the knee. The statue has a rosy complexion and a long beard. He wears a robe adorned with patterns of shou, the character of longevity, and red shoes. His seat has decorated with dragons' heads on the base and on its back is decorated with tiger design. Accompanying the Earth God are the Tiger General and Dog General, both dressed in golden armor with might looks.

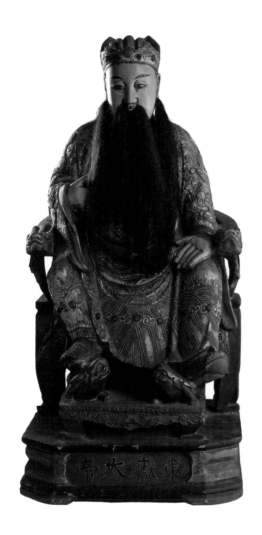

東嶽大帝

材質：木
年代：待考
尺寸：29.5✕59✕28 公分

即泰山神，是山峰的神化及人格化。古人漢人就有崇拜「五嶽」的習慣，即：東嶽泰山、南嶽衡山、西嶽華山、北嶽恒山及中嶽嵩山。泰山長久以來就是帝王設壇祭祀及封禪之地，故從泰山神格化的東嶽大帝自然成為五嶽之首，後來更成為主掌幽冥一切的主神。

Great Emperor of the Eastern Peak

Material: Wood
Era: To be determined
Dimensions: 29.5✕59✕28 cm

The Great Emperor of the Eastern Peak refers to the god of Mount Tai and is the deification and personification of mountain peaks. Ancient Han people were accustomed to worshiping the "Five Peaks," namely: Mount Tai of the Eastern Peak, Mount Heng of the Southern Peak, Mount Hua of the Western Peak, Mount Heng of the Northern Peak, and Mount Song of the Central Peak. Mount Tai has long been the site for imperial altars to pay homage to heaven and earth. Thus, the Great Emperor of the Eastern Peak naturally became the chief of the Five Peaks and later became the main deity overseeing all matters of the underworld.

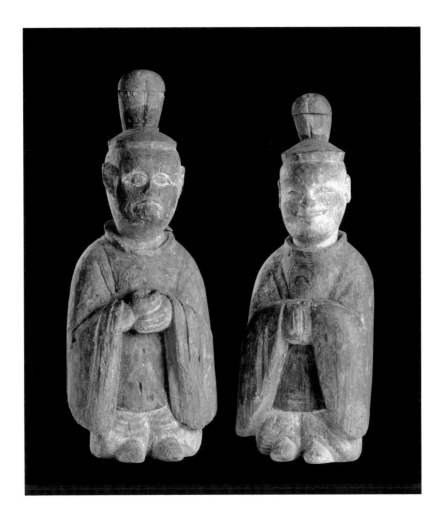

山王神像

材質：木雕上彩
年代：室町初期（西元1336-1476年）
尺寸：**14.5**×**37.3**×**9** 公分；
13.1×**35**×**8.8** 公分

在日本，幾乎每座山都有被當地民眾所崇拜的神靈，統稱為「山王」。這對神像來自著名的比叡山，左側的是大行事神，右側的則是山末神。雖然山王的曼陀羅圖在日本廣泛流傳，但做成雕像的山王神像卻是非常稀有。

Statues of Sanno (Mountain King)

Material: Painted wood
Era: Muromachi period (1336-1476 CE)
Dimensions: 14.5×**37.3**×**9 cm; 13.1**×**35**×**8.8 cm**

In Japan, nearly every mountain has a deity worshiped by the local people, collectively known as "Mountain Kings." These statues came from the famous Mount Hiei, with the left one representing Daigyoji, the deity of major events, and the right one representing Yamasue kami, the deity of the mountain peak. Although mandalas depicting Mountain Kings are widely circulated in Japan, statues of Mountain Kings are very rare.

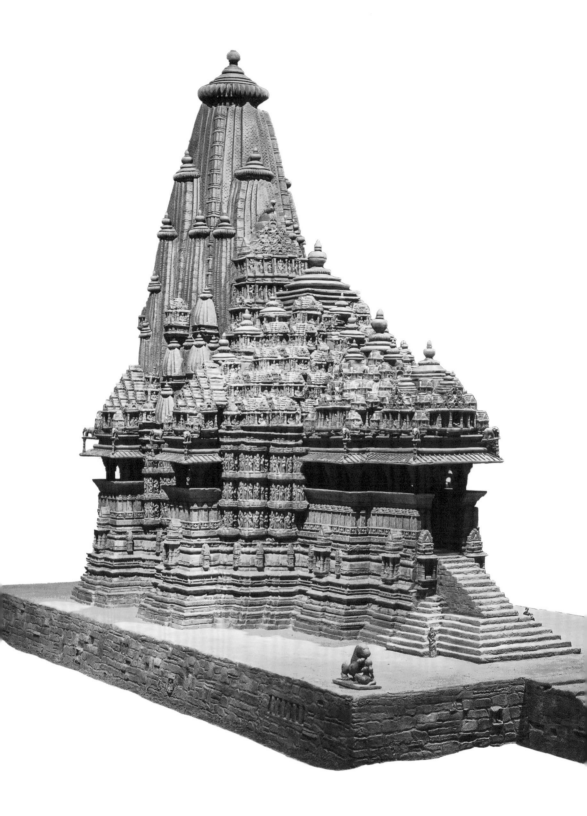

坎德里雅濕婆神廟

宗教：印度教
建造時期：西元十至十一世紀
建造地：印度

濕婆神廟是供奉印度教濕婆的寺廟。濕婆被視為毀滅與再生之神，同時與喜馬拉雅山有著深厚的關係，據信濕婆神廟的造型可能受到喜馬拉雅山的啟發。由陡峭台階進入，經過門廊與大廳才至聖壇。外牆刻滿生動的神獸與飛天雕像，並有愛侶交媾的細膩雕刻。基座牆面花草紋樣極為繁複，以蓮花、半圓及壺形雕刻為主。

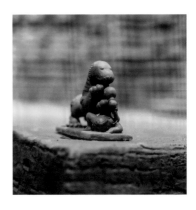

Kandariya Mahadeva Temple

Religion: Hinduism
Construction Period: 10th to 11th century CE
Location: India

The Kandariya Mahadeva Temple is dedicated to the Hindu deity Shiva. Shiva is regarded as the god of destruction and regeneration, and is also deeply associated with the Himalayas. It is believed that the appearance of Kandariya Mahadeva Temple may be inspired by the Himalayas. One enters through steep steps, passing through a porch and a hall before reaching the sanctuary. The exterior walls are filled with lively carvings of mythical beasts and celestial beings, as well as intricate carvings of amorous couples. The patterns on the base wall are extremely complex, featuring lotus, semicircular, and pot-shaped carvings.

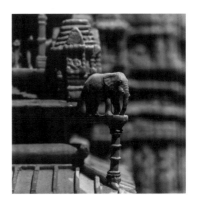

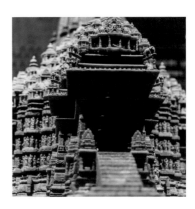

水
Water

水擁有流動與變遷的特性，從井水到河川，再到浩瀚無邊
的海洋，水與我們緊密相連，水是我們意識的組成，地球
和人體有70%都是水做的；而在宗教信仰中，水更象徵著
內心的潔淨與轉化的沉思，是祭祀和洗禮中的重要元素。

Water has the characteristics of flow and change. From well water, rivers, to
the vast and boundless ocean, water is closely linked to us. Water composes
our consciousness. 70% of the Earth and human body are made of water.
In religious beliefs, water symbolizes inner purity and transforming
contemplation is an important element in rituals and baptisms.

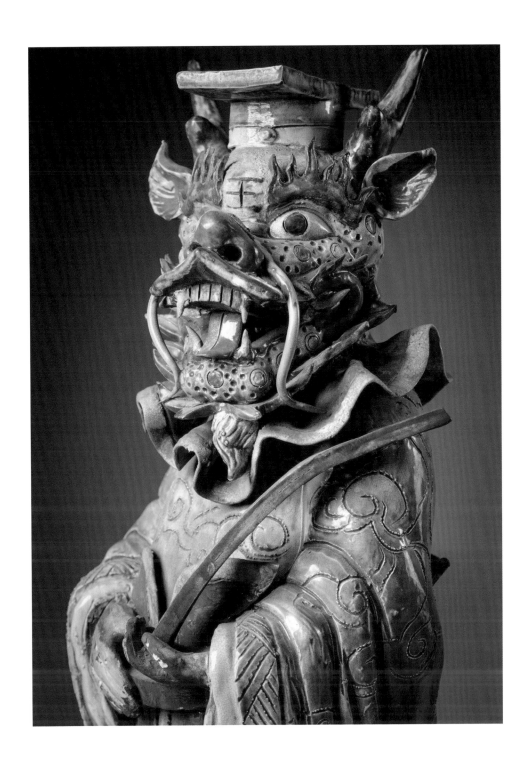

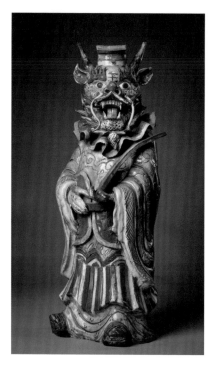 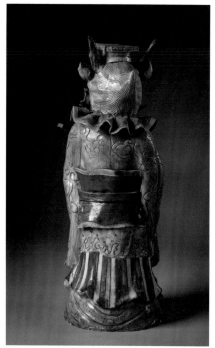

東海龍王像

材質：瓷
年代：日治時期
尺寸：**19×52.5×18 公分**

「龍」為古代神話的四靈獸之首，是中國相當獨特的神靈信仰，形象非禽非獸，有鱗有角，嘴邊有鬚，足似鷹爪，能上天入地，翻雲覆雨，後逐漸演變為主掌海水與雨水的神靈。民間遇水旱災時，即祈求龍王消災解厄。本品為東海龍王瓷像，龍王面朝前而半側身站立，張口露齒，頭戴平天冠，身穿青色朝服，腰著袍肚，左手持笏，右手扶玉帶，呈現上朝天庭的模樣。龍王的朝服上有波紋，領口特意圍上皺褶狀的圍帕，形似波浪，既表現龍王為水族之首的身分，也使其神態更加生動。

Statue of Dragon King of the East Sea

Material: Painted pottery
Era: Japanese colonial period (1895-1945 CE)
Dimensions: 19×52.5×18 cm

The "dragon" is the foremost among the four spiritual creatures of ancient mythology and represents a unique divine belief in China. It is neither bird nor beast, with scales and horns, whiskers by its mouth, and feet like eagle's claws. It has the power to ascend to the heavens, dive into the earth, turn clouds and bring rain. Over time, it gradually evolved into a deity in charge of the seas and rainwater. In times of drought or flood, people pray to the Dragon King to dispel disasters and alleviate misfortune. This object is a porcelain figure of the Dragon King of the East Sea. The Dragon King stands facing forward with a slight turn to the side. His mouth is open and reveals his teeth. Wearing a flat celestial crown, he is dressed in a blue court robe, with a robe around his waist. Holding a tablet in his left hand and touching his jade belt with his right hand, presents the appearance of attending the celestial court. The Dragon King's court robe is adorned with wave patterns, and the collar is deliberately surrounded by a pleated scarf, resembling waves. This not only signifies the Dragon King's status as the leader of the aquatic creatures but also adds vivacity to his demeanor.

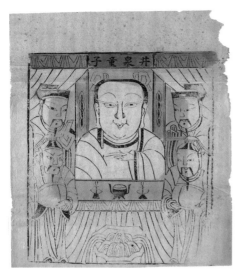

井泉童子，為主掌井泉水源的神靈，與井神意義相同，明代時即有「小聖井泉童子」的記載，昔時人們定時祭拜，以祈求日常用水的順利。圖中井泉童子頭紮雙髻，左右分立侍者；香案下方繪一口湧泉井。

Statue of Well-Spring Child

Material: Paper
Era: Qing Dynasty (1644-1912 CE)
Dimensions: 28×31.6 cm

The Well-Spring Child is a deity in charge of well and spring water, similar in meaning to the Well God. There was already records of the "Little Saint Well-Spring Child" since the Ming Dynasty. People regularly worshipped to ensure a smooth supply of daily water. The image depicts the Well-Spring Child with double buns on the head, flanked by attendants, with a gushing well shown below the incense burner table.

井泉童子

材質：紙
年代：清代
尺寸：28×31.6 公分

總管河神

材質：紙
年代：清代
尺寸：28.1×31.1 公分

河神，又名「河伯」、「水神」。祭祀河神的傳統自上古時代即有，秦漢時期統一將四瀆（江、河、淮、濟）稱作河神，列為國家祀典之一，民間對河神的形象，多認為是白龍、大魚或人面魚身；魏晉以後，道教對民間諸神進行整理，將河神納入其神仙體系，被視為「得道之人所補」的仙官，河神才逐漸人格化。

Supervising River God

Material: Paper
Era: Qing Dynasty (1644-1912 CE)
Dimensions: 28.1×31.1 cm

The River God, also known as "Hebo River Lord" or "Water God", has been worshiped since ancient times. During the Qin and Han dynasties, the four major rivers (Yangtze River, Yellow River, Huai river, and Ji River) were collectively referred to as River Gods included in the national sacrificial ceremony. The folk's image of the River God is that of a white dragon, a large fish, or a human with a fish body. After the Wei and Jin dynasties, Daoism organized various folk deities and included the River God into its celestial system. Gradually personified, the River God was seen as an immortal official "supplemented by those who attained the Dao".

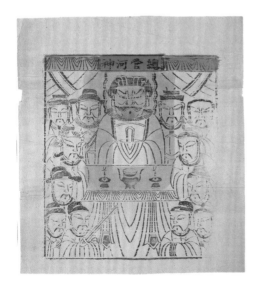

火
Fire

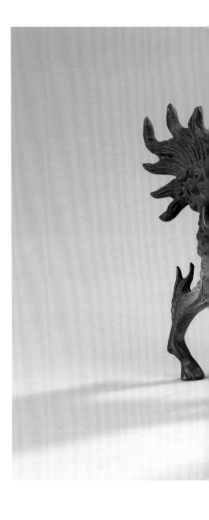

火蘊含著無盡的熱力與光明。是強烈意志的化身，它賜予我們熟食，帶來溫暖。而火也被視為一種提昇的力量，有著毀滅與重生的兩極性。在宗教信仰中，火也是與天地溝通的媒介，通過焚燒，我們得以與上蒼或冥府進行對話。

Fire contains endless heat and light. It is the embodiment of strong will and grants us cooked food and warmth. Fire is also seen as a power of elevation with the dual nature of destruction and rebirth. In religious beliefs, fire is also a medium for communication with heaven and earth. Through burning, we can converse with heaven or the underworld.

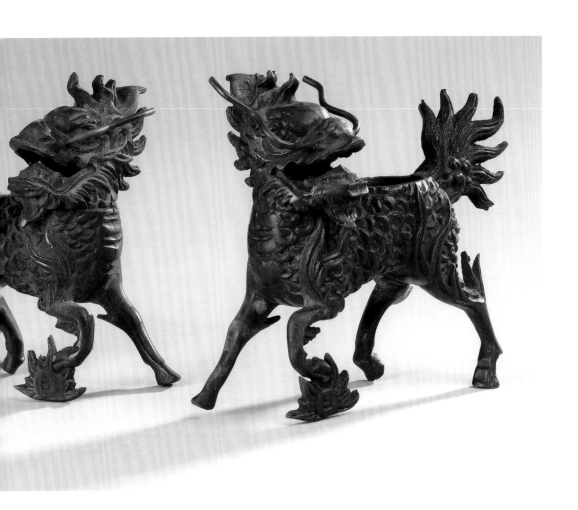

火麒麟薰爐

材質：銅
年代：待考
尺寸：**16.8×14.5×8 公分**

麒麟為中國神話傳說中的神獸，口能吐火，
聲音如雷，相傳只在太平盛世，或世有聖人
時此獸才會出現，是祥瑞象徵。此對麒麟香
爐，頭頂雙角，雙目圓睜有神，鼻部突出，
張口露齒，鬃髯整齊俐落，身軀健碩，四肢
關節處飾火焰紋並前蹄踩日輪，呈現疾趨姿
態，而腹內中空，為的是焚香之用。

Fire Qilin-shaped Incense Burner

Material: Copper
Era: To be determined
Dimensions: 16.8×14.5×8 cm

The qilin is a mythical creature with the ability to breathe fire and
roar like thunder in Chinese folklore. It is said to appear only
during times of peace and prosperity or when a sage is present.
Qilin is an auspicious symbol. This pair of qilin-shaped incense
burners features two horns atop their heads, eyes wide open,
protruding noses, open mouths showing teeth, neatly groomed
manes, and robust bodies. Their limbs are adorned with flame
motifs, and their front hooves rest on sun discs. All suggests a
swift motion. The hollow interior is designed for burning incense.

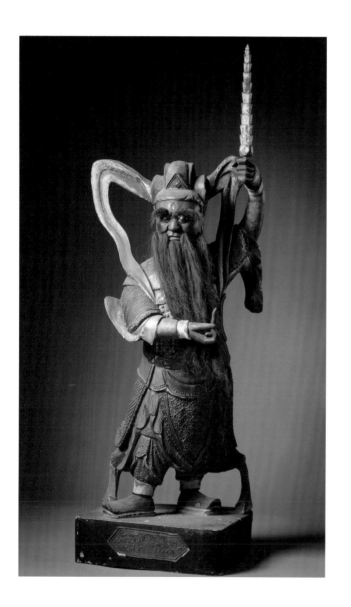

王天君

材質：木
年代：待考
尺寸：30.5×87.5×25 公分

又被稱作「王靈官」，被奉為火府天將，負責守衛天庭的凌霄寶殿。是道教的護法神，具有控制雷火的能力。

本尊王天君紅面赤髮，紅鬍鬢茂密及胸，雙眼圓睜面貌威武，額上有第三隻眼；左手持鞭，右手持靈官訣；身穿戰甲，腰繫虎裙，立身披有雲帶。

Wang Tianjun

Material: Wood
Era: To be determined
Dimensions: 30.5×87.5×25 cm

Also known as "Wang Lingguan," Wang Tianjun is revered as a heavenly general of the fire palace, responsible for guarding the Lingxiao Hall of heaven. He is a protector deity in Daoism with the power to control thunder and fire.

The statue of Wang Tianjun shows him with a red face, red hair, a dense red beard covering the chest, eyes wide open with a majestic appearance, and a third eye on the forehead. He holds a whip in the left hand and makes his signature gesture with the right hand. He wears an armor with a tiger skirt around the waist and a celestial scarf draped over the body.

灶君

材質：木
年代：待考
尺寸：13.5×21×11 公分

道教稱「司命真君」，民間通稱灶君、灶神。為古禮中祀灶與司命之神，有說法是祝融的化身。民間則傳說為玉帝之子，因過失而被降至人間家戶成為灶神，監察百姓言行善惡，直到年底送神日時，才上天庭向玉帝稟報。本件藏品，臉色朱紅，臉型輪廓圓潤，雙眼半睜，頭戴梁冠，身著寬袖蟒袍，挺身端坐，椅前有踏几，衣襬自然垂下，形象生動。

Stove God

Material: Wood
Era: To be determined
Dimensions: 13.5×21×11 cm

"Siming Zhenjun" in Daoism is commonly referred to as the Stove God or Kitchen God in folk belief. He is the deity of the stove and the Deified Judge of Life in ancient rituals. He is also said to be the incarnation of Zhurong. Folklore also describes him as the Jade Emperor's son who was demoted to the human world to be the Stove God due to a mistake; he monitors the good and evil deeds of the people until the end of the year when he ascends to heaven to report to the Jade Emperor. This artifact vividly shows him with a vermilion and round face and half-open eyes. He wears a ritual crown, is dressed in a wide-sleeved python robe, and sits upright with a footrest in front. His robe naturally drapes down.

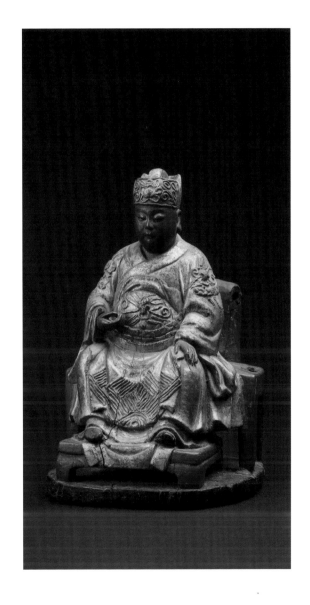

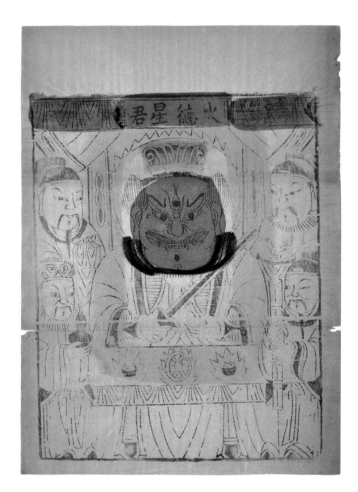

火德星君

材質：紙
年代：清代
尺寸：27✕36.6 公分

又稱「火官大帝」，即為火神。
乃五星中火星中的「熒惑星」，
古人以為南方之神主火，故曰火
德星君，其來源有祝融、炎帝、
回祿等說法，掌管天下一切火之
事物。臺灣消防人員多有奉祀火
德星君之俗，或同祀水德星君，
以祈斂火煞。

Fire Lord

Material: Paper
Era: Qing Dynasty (1644-1912 CE)
Dimensions: 27✕36.6 cm

Fire Lord, also known as "Huoguan
Dadi," represents the fire deity
corresponding to "Mars" of the fire
planets. Ancient people believed that
the god of the south governed fire,
hence the name Fire Lord. Its origins
are associated with figures such as
Zhurong, Yan Emperor, and Huilu,
overseeing all fire-related matters in the
world. In Taiwan, firefighters commonly
worship the Fire Lord and sometimes
alongside the Shuide Xingjun Water
Lord, to pray for the containment of fire
disasters.

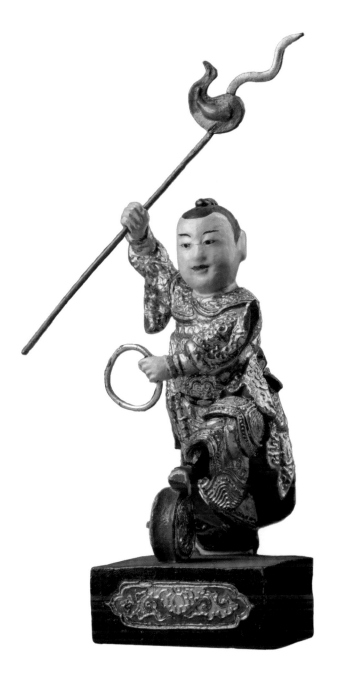

哪吒太子立像

材質：木
年代：待考
尺寸：6×15×5.2 公分

又名為「中壇元帥」。此尊哪吒
頭綁單髻作童子狀，身穿戰甲；
右手持火尖槍，左手持乾坤圈，
腳著皂靴踏風火輪，為臺灣典型
的哪吒造型。

Statue of Prince Nezha

Material: Wood
Era: To be determined
Dimensions: 6×15×5.2 cm

Also known as "Marshal of the Central
Altar." This statue depicts Nezha with
a single topknot hairstyle, dressed in
battle armor. He holds a fire-tipped
spear in his right hand and a Universe
Ring in his left hand, wearing black
boots and standing on wind-and-fire
wheels. This representation is a typical
depiction of Nezha in Taiwan.

雷
Thunder

雷電是大氣對流層靜電放電現象所產生的光和聲音，遠古
人類因對自然現象的無知使它們畏懼雷電，對他們而言，
雷電是力量、震懾的象徵，同時也代表神的聲音。

Thunder and lightning are the light and sound produced by the electrostatic
discharge in the troposphere of atmosphere. Ancient humans were afraid
of thunder and lightning due to their ignorance of natural phenomena. For
them, thunder and lightning represent power and awe, as well as the voice
of the gods.

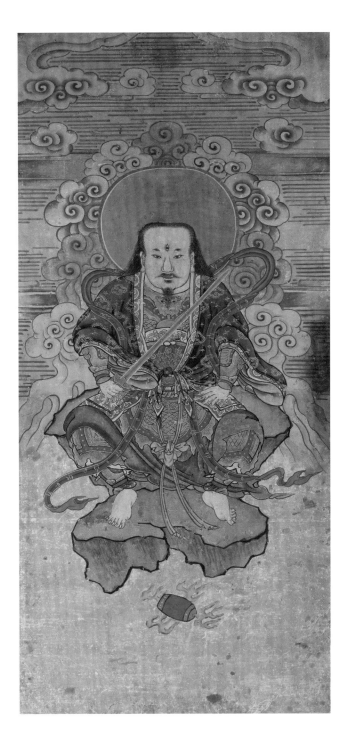

雷祖大帝道壇畫

材質：紙
年代：待考
尺寸：36.9×80.2 公分

道教從十二世紀開始逐漸形成
「雷法」的法術觀念，由此建構
出一套天界的管理雷霆官僚系
統，此幅道壇畫的畫面布局結
構，以雷祖大帝居中，其白面散
髮，額生三目，背後有彩色祥雲
擁護；其身穿黑袍綠裳，內著金
甲且肩披紅帶，持劍跣足，端坐
山岩，面前有一個散發火光的雷
鼓，象徵雷聲鼓動。

Grand Emperor of Thunder Daoist Altar Painting

Material: Paper
Era: To be determined
Dimensions: 36.9×80.2 cm

Daoism gradually formed the concept
of "Thunder Rites" since the 12th
century and constructed a celestial
bureaucracy to manage thunder.
This painting of Daoist altar depicts
the Grand Emperor of Thunder in the
center. He has a pale face with loose
hair and a third eye on his forehead.
Colorful auspicious clouds are in the
background. He wears a black robe
and green garment with golden armor
underneath and a red sash over his
shoulders. Barefoot and holding a
sword, he sits upright on a rocky
mountain. A thunder drum in his front
emits sparks of fire, symbolizing the
sound of thunder.

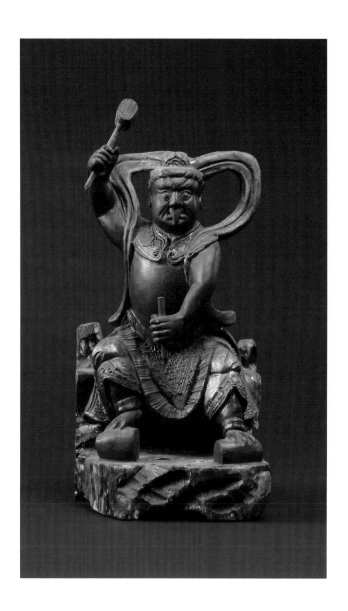

雷神

材質：木
年代：待考
尺寸：15×30.5×13 公分

雷神為神話中職司打雷的神祇，最早的形象為動物，在《山海經》中即有「雷獸」的說法，到了明清時期，雷神的形象才逐漸統一，成為今日所見的鳥嘴雷神形象。

此件藏品，呈現精怪造形。凸眼圓睜，右手握稜錘高舉，左手握鑿子，呈欲擊狀。頭戴小冠，肩披布巾，下半身著長褲，褲外圍甲裙，而足如鷹爪，立站於臺座上。

Thunder God

Material: Wood
Era: To be determined
Dimensions: 15×30.5×13 cm

Thunder God is the deity in charge of thunder in mythology. Its original appearance is an animal which is known as "thunder beast" mentioned in the Classic of Mountains and Seas. By the Ming and Qing dynasties, the image of the Thunder God gradually unified into the bird-beaked Thunder God seen today.

This artifact presents a fantastical form. With bulging eyes, he holds a ridged hammer aloft with his right hand, holds a chisel in his left hand, and is ready to strike. He wears a small crown, a cloth draped over the shoulders, long pants, and an armor skirt outside the pants. He stands on the pedestal with his eagle-claw-like feet.

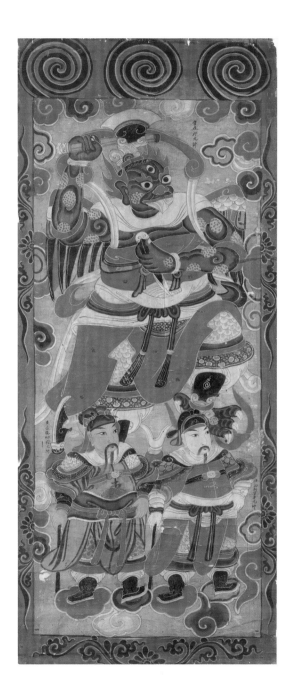

雷霆鄧元帥

材質：紙
年代：西元1846年
尺寸：49╳119 公分

雷霆鄧元帥，是道教中重要的護
法神，被認為是雷部諸神中的執
法將軍。在畫像中，鄧元帥身披
鎧甲，手持雷斧，威風凜凜。
祂擁有三隻眼睛、鳥喙、背後有
翅，雙足如鷹爪，畫面被五色祥
雲環繞，增添神祕與莊嚴之感。
而畫面下方有其部將張元帥和辛
元帥，分立兩側，整體畫象徵著
雷霆萬鈞的正義力量。

Marshal Deng of Thunder

Material: Paper
Era: 1846 CE
Dimensions: 49╳119 cm

Marshal Deng of Thunder, a significant
protective deity in Daoism, is regarded
as the enforcing general among the
gods of the Thunder Division. In the
depiction, Marshal Deng is adorned
in armor, wielding a thunder axe,
exuding an imposing presence. He
possesses three eyes, a bird's beak,
wings on his back, and eagle-like
talons. The image is encircled by five-
colored auspicious clouds, enhancing
its mysterious and solemn aura. Below
in the image, his lieutenants, Marshal
Zhang and Marshal Xin, are positioned
on either side, collectively symbolizing
the formidable and righteous power of
thunder.

鳥獸草木
Flora and Fauna

在當今世界，人口和動物群體都不斷增長，我們與動物的關係究竟是什麼？在許多宗教中，動物被視為神聖或具有神性的存在，有些動物來自傳說，有些原為動物後升格成為神祇，另一些則成為神明的坐騎或夥伴。這些觀念反映了人類與自然之間的緊密連結。不僅是動物，一些具有象徵性意義的植物如蓮花或梣木，也在宗教中占有重要地位。

In today's world, as the populations of humankind and animals continually increase, what exactly is our relationship with animals? In many religions, animals are regarded as sacred or divine beings. Some animals originate from legends; some were initially animals and later elevated to deities; while others have become the mounts or companions of gods. These concepts reflect the close connection between humans and nature. Not only animals, but also certain plants with symbolic significance, such as the lotus or the ash tree, hold important positions in religions.

雪獅
材質：銅鎏金
年代：西元十六世紀
尺寸：31.2×26.3×8.6 公分

雪獅，生活在最高的山區，象徵著西藏的山脈與冰川，喜樂與無畏，是守護著西藏高原的聖獸，有著崇高的地位。此件呈舞立姿勢，獅身後足前後站立，兩前足向上高舉，姿態頗為擬人。而瞠目咧嘴，露出尖牙與舌，鬃毛濃密如火，此造像威嚴且具張力，為寺院抬舉大型尊像法座之用。

Snow Lion
Material: Gilt copper
Era: 16th century CE
Dimensions: 31.2×26.3×8.6 cm

The snow lion lives in the highest mountains, represents the mountains and glaciers of Tibet, joy and fearlessness, and is the sacred beast guarding the Tibetan Plateau, holding a lofty status. This piece is shown in a dancing posture, with the lion's hind legs standing front and back, and both forelegs raised high, in a very anthropomorphic stance. With wide eyes and a gaping mouth, it shows its sharp teeth and tongue. The dense mane is like fire. Majestic and full of tension, this statue is used for lifting large sacred statues in temples.

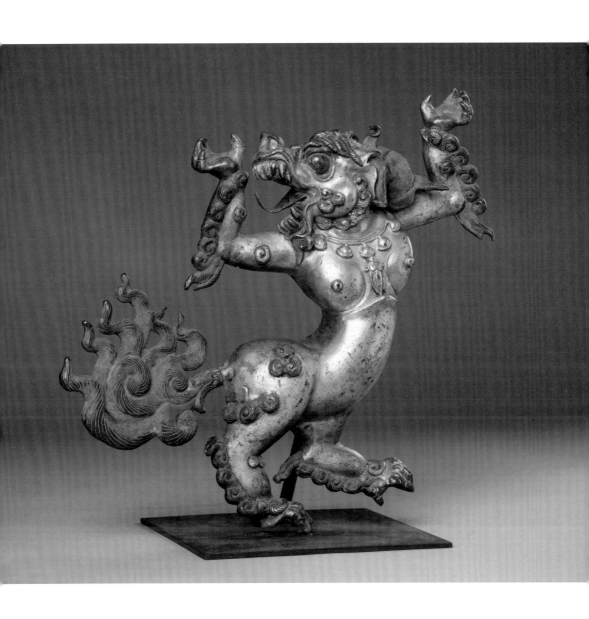

大鵬金翅鳥

材質：礦石
年代：西元十到十一世紀
尺寸：66×40×24 公分

大鵬金翅鳥，或稱「迦樓羅」，乃印度神話中的一種神鳥，祂擁有一對龐大的雙翼，可搧起颶風、撼動天地，被視為力量和勇氣的象徵，因其羽翼散發出陣陣耀眼金光，所以稱「金翅鳥」。祂是主神毗濕奴的坐騎，常被描繪為天空之主，象徵自由。此外，大鵬金翅鳥，轉至藏傳佛教，也被虔誠地信奉，認為其代表慈悲與智慧，可解除乾旱，並帶來能農作物的豐收。

Garuda

Material: Stone
Era: 10th to 11th century CE
Dimensions: 66×40×24 cm

The golden-winged bird also known as "Garuda", is a divine bird in Hindu mythology. It has enormous wings and is capable of stirring up storms and shaking the heaven and earth. The Garuda symbolizes strength and courage with its wings radiating dazzling golden light. Garuda is the mount of the supreme deity Vishnu and is often depicted as the lord of the sky, symbolizing freedom. In Tibetan Buddhism, the Garuda is revered for its compassion and wisdom, believed to bring relief from drought and ensure bountiful harvests.

巴斯泰特

材質：青銅
年代：古埃及後期
尺寸：6.5×15.8×4.3 公分

巴斯泰特女神在古埃及後期極受崇拜，被視為母獅神、太陽女神、貓女神，也是家宅的守護神。常被描繪為身著緊身服的貓頭女神。這尊雕像展示祂左手持盾的姿態，表達出守護與力量的象徵。在希臘統治的時期，更進一步被轉化成代表月亮的神明。

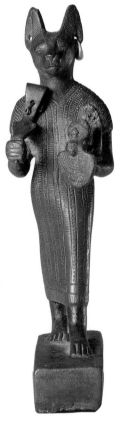

Statuette of Bastet

Material: Bronze
Era: Late Period of ancient Egypt (664-332 BCE)
Dimensions: 6.5×15.8×4.3 cm

The goddess Bastet was highly revered in the Late Period of Ancient Egypt and was regarded as the lioness goddess, sun goddess, cat goddess, and the protector of the home. She is often depicted as a cat-headed woman in a tight-fitting dress. This statuette shows her holding a shield in her left hand and symbolizes protection and strength. During the Greek rule, she was further transformed into a deity representing the moon.

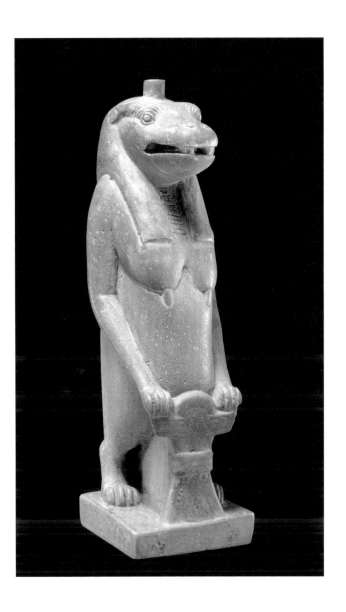

妲烏蕾特

材質：彩陶
年代：到托勒密時期
尺寸：3.5×8.5×4.1 公分

在古埃及被稱為「偉大之神」，是
女性生育時期的守護神。祂的形象
為一尊直立的懷孕河馬，擁有獅子
的腳和鱷魚的尾巴，象徵著力量與
保護。妲烏蕾特的雕像通常被置於
家中，祈求母親分娩安全及孩童健
康成長。

Statuette of Taweret

Material: Faience
Era: 664-332 BCE
Dimensions: 3.5×8.5×4.1 cm

Known as the "Great Goddess" in
ancient Egypt, she is the protector
of women during childbirth. Her
image is that of an upright pregnant
hippopotamus with lion's feet and a
crocodile's tail and symbolizes strength
and protection. Statues of Taweret were
usually placed in homes to pray for the
safe delivery of mothers and the healthy
growth of children.

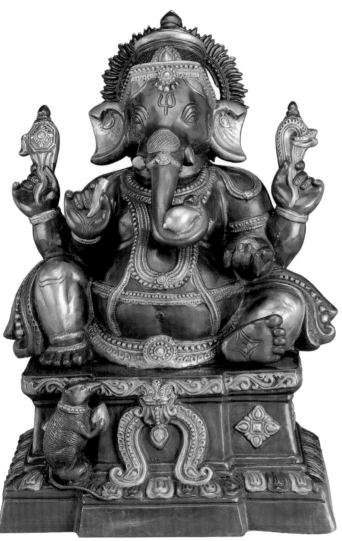

象頭神

材質：黃銅
年代：西元二十世紀
尺寸：38.2×53.8×29 公分

象頭神是印度神話中濕婆與雪山女
神的兒子，以象頭人身、肥胖短小
的形態和僅餘一根象牙而聞名。祂
以善良的性格著稱，被視為智慧的
化身。據說，為了書寫史詩《摩訶
婆羅多》，而折下自己的象牙。象
頭神的座騎是一隻與其體型不匹配
的老鼠，象徵著掃除障礙的能力。

Ganesha (Elephant-headed Deity)

Material: Brass
Era: 20th century CE
Dimensions: 38.2×53.8×29 cm

Ganesha is the son of Shiva and Parvati
in Hindu mythology. His distinctive
appearance includes an elephant
head, a portly body, and a single
tusk. Ganesha is renowned for
his benevolent nature and is
considered the embodiment
of wisdom. Legend has it that
he broke off his own tusk to write
the epic Mah⊠bh⊠rata. His mount is a
mouse, which is disproportionate to his
size. It symbolizes his ability to remove
obstacles.

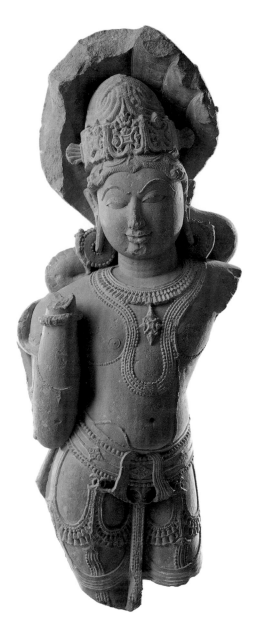

那伽

材質：砂岩
年代：西元十世紀
尺寸：39.5×114×26 公分

印度神話中的蛇神，掌管水源、
河流與大海，是守護地下珍寶的
神祇，並具有造雨之能，帶來豐
收。祂的擬人化形象是面貌俊美
的年輕男子，頭戴寶冠，佩戴項
鍊和耳環，其背後的斗蓬由一條
七頭眼鏡蛇所形成。神像的左臂
已殘，右手亦失，雙腿自大腿以
下部份已殘失。

Nāga (Serpent Deity)

Material: Sandstone
Era: 10th century CE
Dimensions: 39.5×114×26 cm

Nāga is the Serpent Deity responsible
for water, river and sea in Hindu
mythology. As a guardian of hidden
treasures, the deity has the power
to bring rain and ensure abundant
harvests. The anthropomorphic
representation is a handsome young
man with a crown, necklaces, and
earrings. His cloak is formed by a
seven-headed cobra. The statue's left
arm is damaged and the right hand
is missing, while the legs are partially
lost.

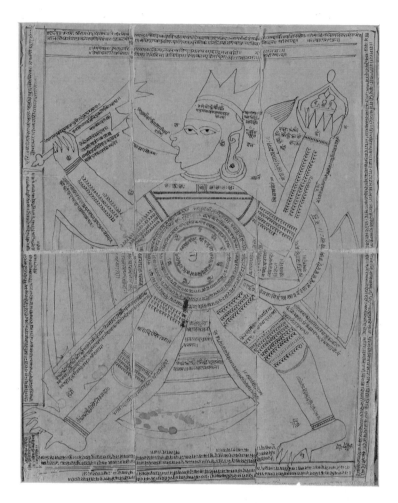

哈奴曼

材質：紙
年代：西元十九世紀
尺寸：51.6×68.3×1.6 公分

是印度史詩《羅摩衍那》中的神猴，由風神與化身
為女猴的天女所生，具有飛行能力和驚人的力量。
猴神的身體不僅代表曼陀羅，還象徵著世界的顯
像，且其四周被咒語所圍繞，反映了印度密教中宇
宙由消極的靈魂（猴神）和積極的世界（曼陀羅）
所組成的觀點。

Hanuman (Monkey Deity)

Material: Paper
Era: 19th century CE
Dimensions: 51.6×68.3×1.6 cm

The Monkey Deity appears in the Indian epic Ramayana.
Born from the union of the Wind God and an apsara
transformed into a female monkey, Hanuman possesses
the ability to fly and incredible strength. His body not
only represents the mandala but also symbolizes the
manifestation of the world. He is surrounded by mantras,
reflecting the view of Indian Tantric Buddhism that the
universe is composed of the passive soul (the monkey
deity) and the active world (the mandala).

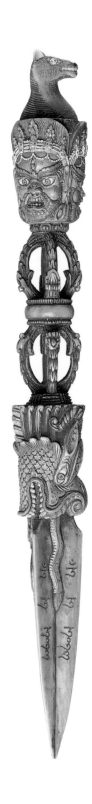

馬頭明王普巴杵

材質：木、象牙
年代：待考
尺寸：27.4 × 9.4 × 5.4 公分

或稱「金剛橛」，原為古印度的
兵器，後被藏傳佛教吸收為法
器。馬頭明王乃是佛教中的護法
神之一，其形象有多種變化，是
佛，是菩薩，也是護法。祂含有
忿怒，降伏的意思，乃是佛教中
的護法神，器物下方為摩羯魚和
三棱前尖，意謂護持降伏一切邪
魔。

Hayagriva Phurpa

Material: Wood and Ivory
Era: To be determined
Dimensions: 27.4 × 9.4 × 5.4 cm

The Phurpa, also known as
"vajvakilaka," was originally an ancient
Indian weapon and later adopted by
Tibetan Buddhism as a ritual instrument.
Hayagriva, the Horse-Headed King,
is one of the dharma protectors in
Buddhism. His image varies including a
Buddha, a Bodhisattva, and a dharma
protector. He embodies wrath and
subjugation, as a protector deity in
Buddhism. The lower part of the object
features a makara fish and a triangular
sharp point, signifying the protection
and subjugation of all demons.

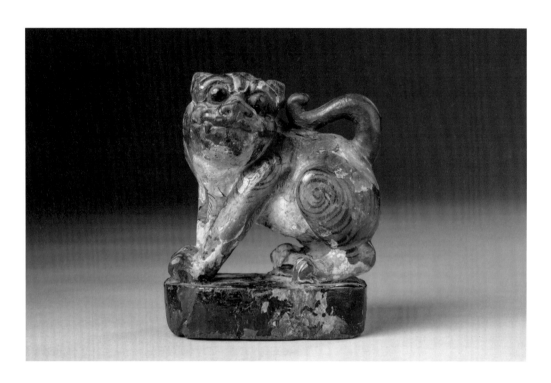

虎爺

材質：木
年代：清代
尺寸：**13**×**16**×**8** 公分

又有「虎爺公」、「虎將軍」等稱呼，最早為山
神、土地公的坐騎，後來演變為保生大帝、媽祖
等諸神的座騎，有驅逐疾癘和鎮守廟宇的作用。
此尊虎爺的造型為一具虎型的動物神像，採前腳
直豎後腿蹲伏翹尾之姿，回首露齒狀。彎曲的蹲
坐之姿，並回眸露齒，模樣傳神可愛。

Tiger Deity

Material: Wood
Era: Qing Dynasty (1644-1912 CE)
Dimensions: 13×**16**×**8 cm**

Tiger Deity, also known as or General Tiger, was originally
the mount of mountain gods and the Earth God. Over time, it
evolved into the steed of deities such as the Baosheng Dadi
and Mazu to expel diseases and guarding temples. The
statue is in the shape of a tiger, with its front legs straight,
hind legs crouched, tail raised, and teeth bared. The curved
crouching posture and the backward glance revealing teeth
give it a vivid and endearing appearance.

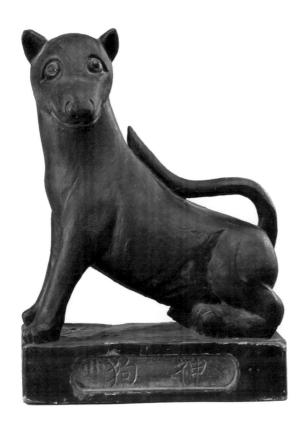

狗神

材質：木
年代：待考
尺寸：26.5×36.5×15 公分

在臺灣民間信仰裡，狗是最常見的動物崇拜。從新石器時代開始，狗與人類的生活便密不可分。人們塑造狗的神像時，原則上多保持狗的原形象。本件狗神像成坐姿，全身漆黑，抬頭仰望左側，像是在期盼什麼，面露憨態，狗尾翹起，貼向後背，後足之間亦能見到生殖器，造像逼真可人。

Dog Deity

Material: Wood
Era: To be determined
Dimensions: 26.5×36.5×15 cm

In Taiwanese folk belief, the dog is the most commonly worshiped animal. Since the Neolithic period, dogs have been inseparable from human life. When people create statues of dog deities, they generally keep the dog's original appearance. This lifelike and endearing statue is shown in all black in a sitting position and looking up to the left as if expecting something with a naive expression. The tail is raised and pressed against the back. The genitals are visible between the hind legs.

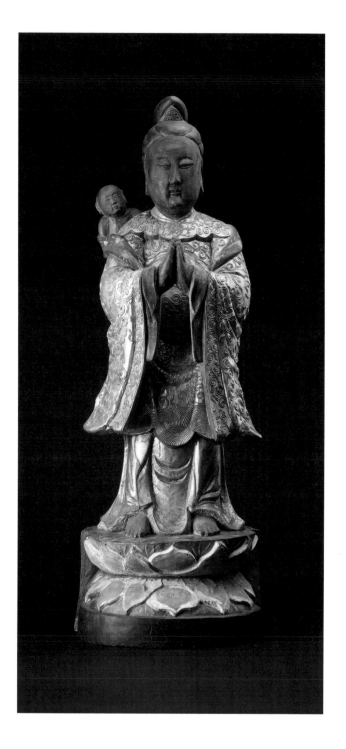

鳥母

材質：木
年代：待考
尺寸：25.5×72.5×27 公分

又稱「婆姐」，主要作為註生娘娘
旁的陪祀，為協助送子、護產、生
育的女性守護神之一。保佑小孩出
生後到十六歲這段期間身心能正常
發育。此件婆姐的造像為立姿的中
年婦女，其赤足立身於蓮花臺座，
神情恭穆採雙手合十的姿態，而肩
上有嬰兒背帶纏繞，右肩上的幼
童，神情放鬆，微微一笑。

Bird Mother

Material: Wood
Era: To be determined
Dimensions: 25.5×72.5×27 cm

Also known as "Pojie," the Bird Mother
mainly serves as a companion deity to
the Zhusheng Niangniang Goddess of
Child Giving. She is one of the female
guardian deities who assist in delivering
children, protecting childbirth, and
fertility. She blesses children to grow with
healthy mind and body from birth until
the age of sixteen. This statue depicts a
middle-aged woman, standing barefoot
on a lotus pedestal, with a respectful
expression and hands pressing together.
A baby carrier is wrapped around her
shoulders, and a relaxed child on her
right shoulder smiles slightly.

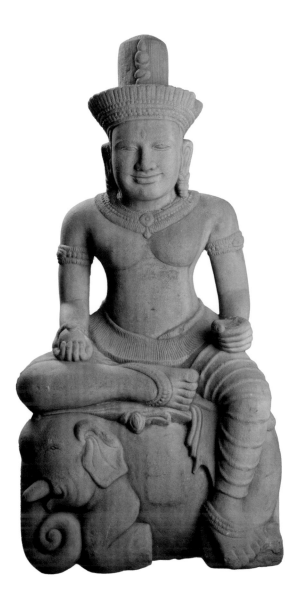

普賢菩薩

材質：礦石
年代：吳哥王朝
尺寸：50×98×27.5 公分

吳哥王朝時期的建築和雕塑風格受到印度
與佛教文化的影響，通過借鑒、融合與創
新，發展出特有的沉穩且圓融的風格。普
賢菩薩為漢傳佛教的四大菩薩之一，是娑
婆世界釋迦牟尼佛的右、左脅侍，被稱為
「華嚴三聖」，普賢以智慧引導行動；以
行動證明智慧，世人也稱之為「大行普賢
菩薩」。此尊佛像造型厚實，面帶微笑、
身著傳統服飾、寶冠，以大象為坐騎。

Samantabhadra Bodhisattva

Material: Stone
Era: Angkor Dynasty (802-1432 CE)
Dimensions: 50×98×27.5 cm

The styles of architecture and sculpture of the
Angkor Dynasty were influenced by Indian
and Buddhist cultures. Through emulation,
integration, and innovation, they developed
a distinctive style that is both stable and
harmonious. Samantabhadra Bodhisattva is
one of the four great bodhisattvas in Chinese
Buddhism, serving as the right and left attendant
to Shakyamuni Buddha in the Saha world.
As one of the "Three Saints of Avataasaka,"
Samantabhadra leads with wisdom and proves
wisdom through action; therefore, also referred
to as the "Great Virtue Samantabhadra." This
robust statue is dressed in traditional attire and
a solid crown with a gentle smile while riding an
elephant.

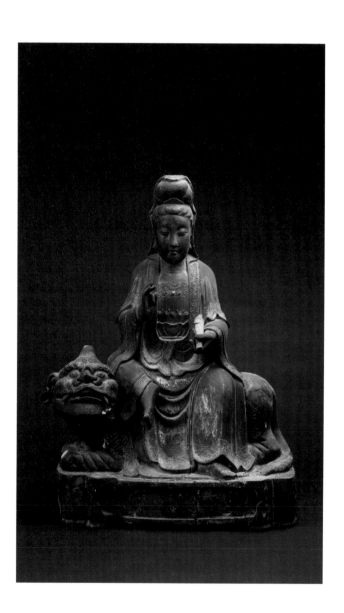

騎犼觀音

材質：木
年代：清代
尺寸：51×70×25.5 公分

又稱「獅吼觀音」，為觀音菩薩的
化身之一，具有極為威猛的力量。
「犼」為一種異獸，據說是龍王之
子，騎犼觀音在明代頗為流行，除
了單獨出現外，有時也會與騎獅的
文殊菩薩和乘象的普賢菩薩成為一
組造像。此尊騎犼觀音面相長圓，
眉彎眼長，左手持經卷，右手掐蓮
花指，身飾繁複華麗的瓔珞，整體
形貌沉穩。而底下的犼，呈蹲伏
貌，張嘴直視前方，神情威武。

Bodhisattva Avalokiteshvar (Riding Hou Guanyin)

Material: Wood
Era: Qing Dynasty (1644-1912 CE)
Dimensions: 51×70×25.5 cm

Also known as Simhanada
Avalokiteshvara (Guanyin of the Lion's
Roar), Bodhisattva Avalokiteshvara is
an incarnation of Guanyin Bodhisattva
with tremendous power. The "hou" is
an exotic creature and is said to be
the son of the Dragon King. During the
Ming Dynasty, Avalokiteshvara became
popular and sometimes appears
alongside the lion-riding Manjushri
Bodhisattva and the elephant-riding
Samantabhadra Bodhisattva. The statue
has an oval face with arched eyebrows
and long eyes, holds a sutra in the left
hand and making the lotus gesture with
the right hand. Avalokiteshvara wears
elaborate and intricate ornaments
and has a dignified appearance. The
hou beneath is crouching and gazing
forward with mouth open, exuding a
majestic aura.

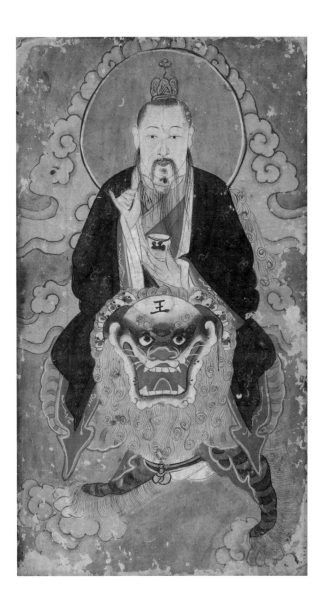

太乙救苦天尊圖

材質：紙
年代：待考
尺寸：19.2×34.5 公分

太乙救苦天尊為道教度亡儀式中職
司救亡魂的神祇，唐代的道教經
典描述太乙救苦天尊騎五色獅子
頭，後世則據此形象轉而描繪九頭
青獅的模樣。此像天尊，左手托淨
水盂，右手捻指，跨騎在九頭青獅
上，其鬃毛怒張，額書「王」字，
像是踩在祥雲之上，正展現神威。

Celestial Venerable of Taiyi Saving the Suffering

Material: Paper
Era: To be determined
Dimensions: 19.2×34.5 cm

Celestial Venerable of Taiyi Saving the
Suffering is a Daoist deity of salvation
for souls in funeral rituals. The Daoist
classics of the Tang dynasty describe
that Taiyi riding a five-colored lion, and
later generations depicted the image of
a nine-headed green lion based on this
record. The Celestial Venerable of Taiyi
holds a clean water container in his left
hand with his right fingers making a
gesture, and straddles a nine-headed
green lion with bristling mane with a
"wang (namely king)" character on its
forehead, as if stepping on auspicious
clouds and showing invincible might.

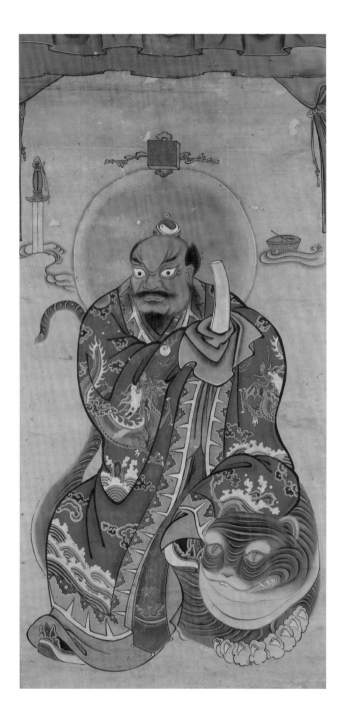

張天師騎虎像

材質：紙
年代：待考
尺寸：89×202 公分

張天師，又名張道陵，東漢天師
道創始人。天師道也被稱為「五
斗米道」，因為加入的信徒必須
捐獻五斗米。此張天師像，頭戴
太極纓冠，身穿紅色蟒袍，跨坐
在虎身上，虎呈現一種祥和的姿
態，神情躍然紙上，畫布上頭以
篆書題寫「陽平治印」。

Zhang Tianshi Riding a Tiger

Material: Paper
Era: To be determined
Dimensions: 89×202 cm

Zhang Tianshi, also called Zhang
Daoling, is the founder of the
Tianshidao (Way of the Celestial
Masters) in the Eastern Han dynasty.
Tianshidao is also called "Way of
the Five Pecks of Rice" because
adherents wishing to join were
required to donate five pecks of rice.
This image of Zhang Tianshi wears
a Taiji crown and a red python robe
and straddles a tiger with a peaceful
demeanor that is vividly present. The
work is inscribed with "yang ping zhi
yin" in seal script.

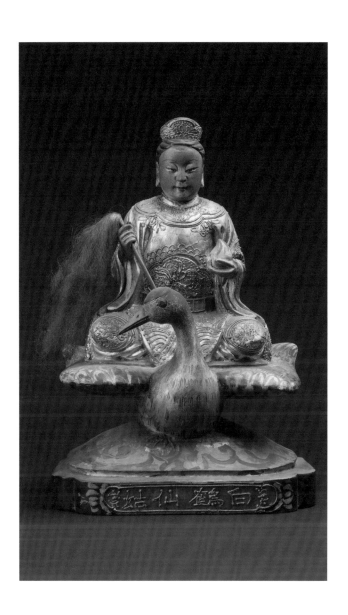

白鶴仙姑

材質：木
年代：待考
尺寸：20.7✕30✕16.2 公分

白鶴仙姑據傳乃是商朝時代聖
賢，歸天後由於九天玄女娘娘推
薦，而在宮協助王母娘娘救世，
為七仙聖賢之一。性情急躁面惡
心善，因本是男子為白鶴山修行
的童子，為王母召化願意幻化女
身，承擔重任，做事明如鏡，專
解凶厄，執拂塵、身穿白衣裙，
腳踏白鶴。

Immortal Lady of White Crane

Material: Wood
Era: To be determined
Dimensions: 20.7✕30✕16.2 cm

The Immortal Lady of White Crane is
said to be a sage of the Shang Dynasty.
After ascending to heaven, she was
recommended by the Mysterious
Woman of the Nine Heavens to assist
the Queen Mother of the West in saving
the world. She is one of the Seven
Immortals. Despite originally being
male, she transformed into a female
to fulfill her duties. She was quick-
tempered with a fierce appearance but
a kind heart. Originally a male disciple
practicing on Mount White Crane, he
was willing to be transformed into a
female form at the behest of the Queen
Mother to take on a heavy responsibility.
Her actions are as clear as a mirror. She
specializes in resolving disasters. She
holds a dust whisk, wears a white robe,
and stands on a white crane.

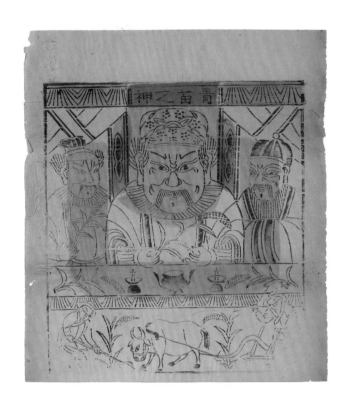

青苗之神

材質：紙
年代：清代
尺寸：28×32 公分

傳統中國是一典型的農業社會，
相關的信仰與崇拜，即成為民間
主要的祭祀內容。青苗之神，顧
名思義即為保佑稻米耕作順利的
神靈，是與農事相關，特有的古
代神靈。

Deity of Qingmiao Seedlings

Material: Paper
Era: Qing Dynasty (1644-1912 CE)
Dimensions: 28×32 cm

Traditional China was a typical
agricultural society and the related
beliefs and worship became the main
content of folk rituals. The Deity of
Seedlings, as the name implies, is the
deity that blesses the rice cultivation
and a unique ancient deity related to
agriculture.

蓮花護符

材質：礦石
年代：待考
尺寸：8×8×2.5 公分

蓮花在佛教中象徵純潔、
智慧和解脫。它生於污泥但
保持潔淨，寓意人在困境中
保持純淨心靈和高尚品德。蓮花
的成長過程象徵修行者從無明到
覺悟。佩戴蓮花護身符被認為能
保護免受負面影響，帶來心靈平
靜，使持有者保持善念與德行。

Lotus Amulet

Material: Stone
Era: To be determined
Dimensions: 8×8×2.5 cm

The lotus flower symbolizes purity,
wisdom, and liberation in Buddhism.
Emerging from muddy waters yet
remaining clean, it signifies maintaining
a pure spirit and virtuous character
in adversity. The growth of the lotus
represents the practitioner's journey
from ignorance to enlightenment.
Wearing a lotus amulet is believed to
protect from negative impacts, bring
peace of mind, and help the wearer
keep good thoughts and virtues.

結錢之木

材質：紙
年代：西元十九至二十世紀
尺寸：77×37 公分

圖中所描繪的樹象徵著致富之
道。樹上的致富教誨，來自於樹
下兩位財富之神，惠比須與大黑
天。其意涵是，如果能在日常生
活中實踐這些教誨，它們將會像
被細心呵護的盆栽一樣，在人們
的心中茁壯成長，並長久影響人
們的一生；樹上的葉片形如錢
幣，象徵著若能讓枝幹茁壯，財
富便會源源不絕。

Tree of Wealth

Material: Paper
Era: 19th to 20th century CE
Dimensions: 77 cm×37 cm

The tree depicts the path to prosperity.
The teachings of prosperity on the tree
is from Ebisu and Daikokuten, the two
wealth deities beneath the tree.
The implication is that if one can
practice these teachings in daily
life, they will grow in one's heart
like a carefully nurtured bonsai,
influencing one's life for a long time.
The coinshaped leaves on the tree
symbolize that wealth will come
endlessly if the branches are allowed to
thrive.

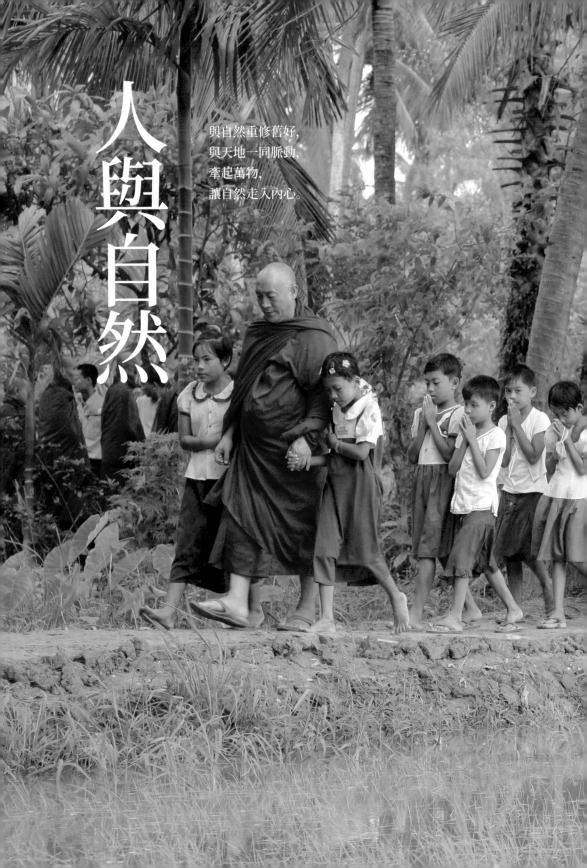

人與自然

與自然重修舊好，
與天地一同脈動，
牽起萬物，
讓自然走入內心。

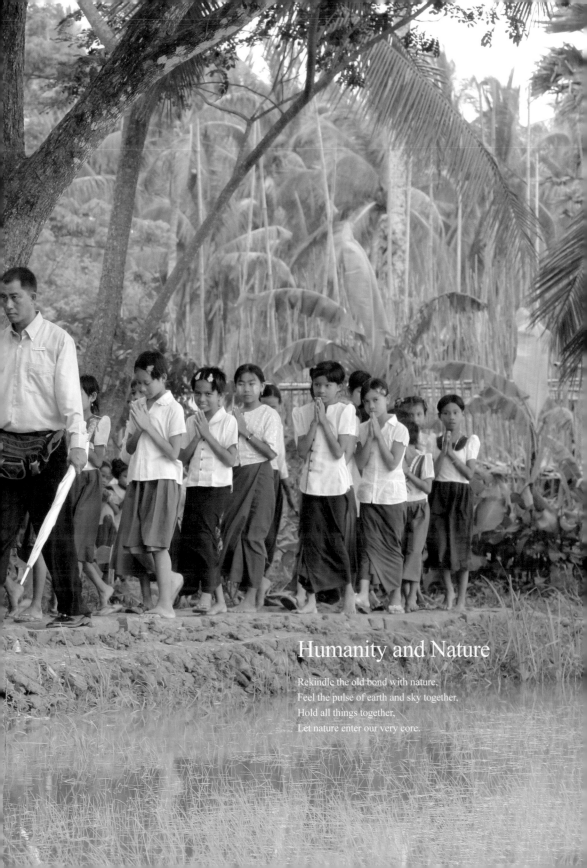

Humanity and Nature

Rekindle the old bond with nature,
Feel the pulse of earth and sky together,
Hold all things together,
Let nature enter our very core.

辟邪信仰
Beliefs to ward off evil

人類長期以來一直尋找與自然力量連結的途徑。這些連結可以透過各種物件來實現，例如馬雅面具所蘊含的動物靈性，以及苗族百鳥衣中所體現對動物圖騰的尊崇。此外八卦牌、石獅子等也具有驅邪避凶的功能。而七星劍和五雷令牌這些法器，被賦予神祕的自然力量，能庇佑並且保護使用者。

Humans have long sought ways to connect with natural forces. These connections can be realized through various objects. For example, the animal spirituality embodied in Maya masks, and the reverence for animal totems expressed in the Miao people's Hundred Birds Garment. Additionally, objects like the plaques of the Eight Trigrams and stone lions also serve to ward off evil and misfortune. Ritual instruments like the Seven-Star Sword and the Five Thunder Tablet to Command Spirits are imbued with mysterious natural powers and offer protection and blessings to their users.

公牛面具

材質：木
年代：西元1930—1960年
尺寸：12.7×17.8 公分

公牛面具在馬雅文化中的「牛之舞」使用，這種舞劇通常在節慶開始時作為祈願的一部分演出，以公牛進城的場景開始，接著進行一系列的鬥牛表演，最終以象徵性地饒恕罪惡來結束整個儀式。面具的牛角之間裝有鈴鐺，置於護墊上，保護舞者免受撞擊。

Bull Mask

Material: Wood
Era: 1930-1960 CE
Dimensions: 12.7×17.8 cm

The Bull Mask is used in the "Dance of the Bull" in Maya culture. This dance drama is often performed as part of a prayer ritual at the beginning of a festival. The festival starts with a bull entering the city, then bullfighting performances, and ends with symbolically the forgiveness of sins. The mask has bells between the horns, placed on a cushion to protect the dancer from impacts.

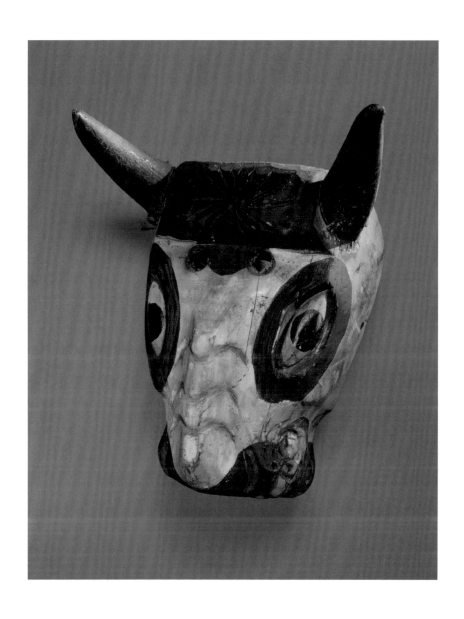

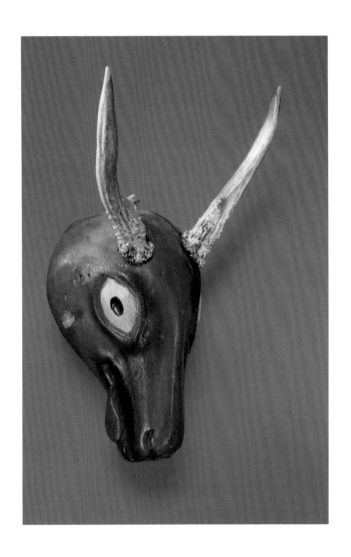

鹿面具

材質：木
年代：西元二十世紀
尺寸：15.9×21.6 公分

猴子面具

材質：木
年代：西元1904—1955年
尺寸：14.6×16.5 公分

鹿面具與猴子面具是馬雅文化中
的傳統面具。鹿面具用於「鹿之
舞」，該舞蹈起源於前西班牙時
期，為中美洲最古老的舞蹈之
一。舞者扮演多種動物，包括老
虎、獅子、猴子等，主要目的為
與動物溝通，並獲得神的同意以
食用鹿肉。後轉化為向聖母瑪利
亞獻舞，以祈神賜福；而猴子面
具不僅出現在「鹿之舞」中，在
多個馬雅儀式中也扮演關鍵角
色。猴子是古代的使者，在儀式
中擔任群眾的管理者以及丑角，
當舞者要在儀式中走過繩索時，
猴子擔任繩索測試者。

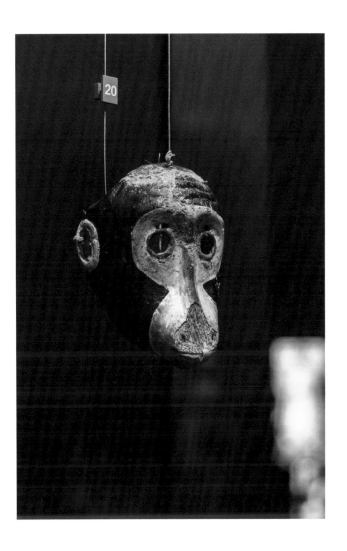

Deer Mask

Material: Wood
Era: 20th century CE
Dimensions: 15.9 × 21.6 cm

Monkey Mask

Material: Wood
Era: 1904-1955 CE
Dimensions: 14.6 × 16.5 cm

The Deer Mask and Monkey Mask are traditional masks in Maya culture. The Deer Mask is used in the "Dance of the Deer," one of the oldest dances in Central America that originated before the Spanish period. Dancers play various animals, including tigers, lions, and monkeys, with the primary purpose of communicating with animals and obtaining divine permission to consume venison. It later transforms into a dance offered to the Virgin Mary for blessings. The Monkey Mask not only appears in the "Dance of the Deer" but also plays a key role in Maya rituals. As a messenger in ancient times, the monkey acts as a crowd manager and jester during rituals. When dancers are crossing the ropes, the monkeys are responsible for testing the ropes.

土地公儺戲面具

材質：木
年代：清末至民初
尺寸：14×24.5×8 公分

儺，本質上是一種鬼神意識，它
源於人類對自然的依附和恐懼。
儺面具，最早是用在驅逐疫鬼的
儺祭活動，後來也用於拜祭天
神、避凶佑民。此儺戲面具屬於
正神面具，土地公的臉型方中帶
圓，長臉長耳，眉眼微彎帶笑，
留長白鬚而覆頷。嘴角上翹，微
笑時牙齒也露了出來，於細節之
處生動地把握住了土地公寬厚仁
愛的性格。

Opera Mask of Earth God

Materia: Wood
Era: Late Qing Dynasty-Early Republic of China
Dimensions: 14×24.5×8 cm

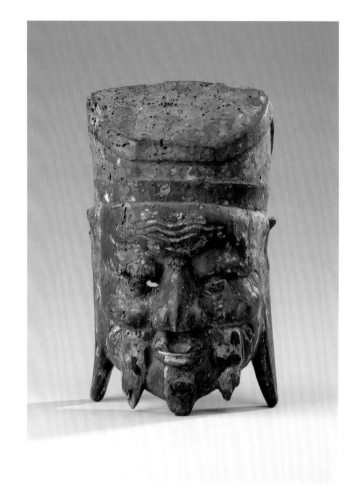

Nuo essentially represents a consciousness of spirits and demons and originates from human dependence on and fear of nature. Nuo masks were initially used in Nuo rituals to expel epidemic demons and later for worshiping deities and protecting the people. This Nuo opera mask belongs to the category of righteous deity masks. The Earth God's face is square with rounded edges. He has a long face, long ears, slightly curved eyebrows, smiling eyes, and a long white beard covering the chin. The corners of the mouth turn upwards and reveal teeth when smiling. The details of the mask vividly shows the generosity and benevolence of the Earth God.

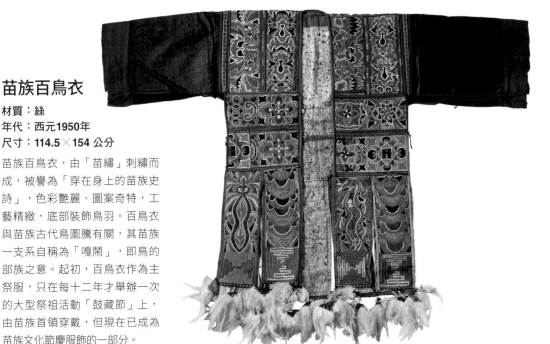

苗族百鳥衣

材質：絲
年代：西元1950年
尺寸：114.5×154 公分

苗族百鳥衣，由「苗繡」刺繡而成，被譽為「穿在身上的苗族史詩」，色彩艷麗、圖案奇特，工藝精緻，底部裝飾鳥羽。百鳥衣與苗族古代鳥圖騰有關，其苗族一支系自稱為「嘎鬧」，即鳥的部族之意。起初，百鳥衣作為主祭服，只在每十二年才舉辦一次的大型祭祖活動「鼓藏節」上，由苗族首領穿戴，但現在已成為苗族文化節慶服飾的一部分。

Miao Hundred Birds Garment

Material: Silk
Era: 1950 CE
Dimensions: 114.5×154 cm

The Miao hundred birds garment, made from "Miao embroidery," is known as the "Miao epic worn on the body." With vibrant colors, unique patterns, and exquisite craftsmanship, the hundred birds garments are decorated with bird

feathers at the bottom. The hundred birds garment is related to the ancient bird totem of the Miao people. One of the subgroups call themselves "Ghab nes," meaning the tribe of birds. Initially, the hundred birds garment was worn by Miao leaders only during the "Guzang festival" a large ancestral worship event held once every twelve years, but it has now become part of the festival attire of the Miao culture.

石獅子

材質：花崗岩
年代：清中葉以前
尺寸：20.5×39×22公分；19×39×22 公分

石獅作為寺廟重要的文物之一，主要功能在於其守護鎮煞、避邪厭勝的威力，因此亦可被視為廟宇厭勝物的一種。獅子約早在東漢傳入中國，民間相信其威猛而有制伏虎豹的威力，故被轉化為具有強大驅邪制煞的靈力，視為祥瑞辟邪之獸。後世即將獅子的形象置於宮殿、衙門或廟埕大門之外，藉以發揮守護、辟邪等功能。

Stone Lions

Material: Granite
Era: Before the middle of Qing Dynasty
Dimensions: 20.5×39×22 cm; 19×39×22 cm

Stone lions, as important cultural relics of temples, primarily serve as guardians and exorcists, thus can also be considered as a type of amulets. The lion was introduced to China around the Eastern Han Dynasty, and people believed in its mighty power to subdue tigers and leopards. Therefore, it was transformed into a powerful force against evil spirits and regarded as an auspicious beast that wards off evil. In later generations, the image of the lion was placed outside palaces, government offices, or temple courtyards to exert its protective and evil-warding functions.

獅子狛犬

材質：木
年代：鎌倉末期
尺寸：29.5×48.5×43 公分；26.1×49×44.8 公分

也稱為「高麗獅子狗」，通常成對擺放在日本神社拜殿前，用以防止危險或邪靈的入侵。其中張口的是獅子，而閉口的是狛犬，張嘴的代表「阿」，閉嘴的代表「吽」。「阿」、「吽」都是梵音，其象徵宇宙萬物的一切，以及生命的一呼一吸。

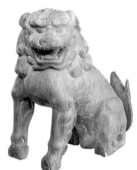

Komainu

Material: Wood
Era: end of Kamakura period (1185-1333 CE)
Dimensions: 29.5×48.5×43 cm; 26.1×49×44.8 cm

Also known as "Korean lion dogs," they are usually placed in pairs in front of the haiden worship hall of Japanese shrines to ward off dangers or evil spirits. One of the displays with an open mouth represents the lion, and the other one with a closed mouth represents the komainu. The mouth-open one represents "a" and the mouth-closed one represents "Un." Both "a" and "un" are Sanskrit syllables, symbolizing everything in the universe and the breath of life.

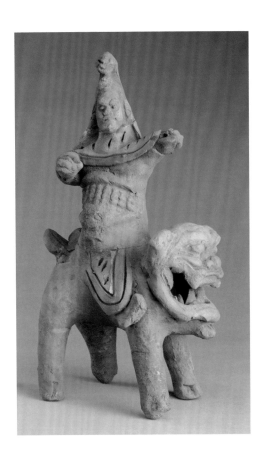

瓦將軍

材質：磚
年代：待考
尺寸：15.5×27.5×11 公分

昔日臺灣及閩南一帶民宅居家屋頂多覆有瓦片，易遭強風掀毀屋宇，民間俗信在正廳的屋頂或中脊上設立風獅爺可以鎮風制煞。因為風神亦稱風師，而古字「師」與「獅」通用，遂有武人騎獅的造型。民間屋頂辟邪物以瓦將軍最具造型之美，武將騎獅出擊，擺出拉弓射箭的姿態，英姿勃發。

General (Tile)

Material: Brick
Era: To be determined
Dimensions: 15.5×27.5×11 cm

In the past, houses and residences in Taiwan and southern Fujian were often roofed with tiles which were easily blown away by strong winds. It was a common folk belief that placing a Wind Lion God on the roof or ridgepole of the main hall could suppress the wind and ward off evil spirits. Since the Wind God is also referred to as and the ancient character for was interchangeable with "lion," there emerged the design of a warrior riding a lion. Among the rooftop figures designed to ward off evil, the General is considered the most aesthetically pleasing. It shows a military general riding a lion while shooting an arrow, exuding a spirited and valiant demeanor.

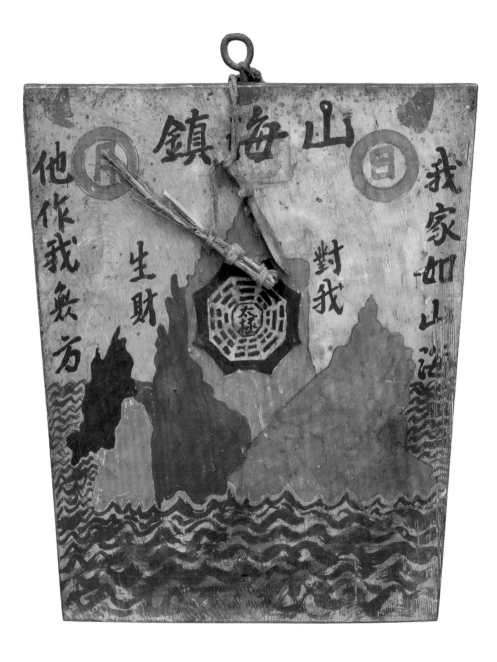

山海鎮

材質：木板上彩
年代：待考
尺寸：22.5×28.4×1 公分

山海鎮繪有山海、日月及八卦等
圖文，上邊尺寸約為八寸代表八
卦、下邊六寸四代表六十四卦、
高一尺二寸代表十二時辰、兩邊
合二十四節氣。常在家宅門楣上
出現，希冀能藉助山、海的力
量，來鎮制門前風水種種沖煞。
偶爾也在山邊、橋亭、河邊或海
邊出現。

Mountains and Seas Plaque

Material: Painted Wood
Era:To be determined
Dimensions: 22.5×28.4×1 cm

The Mountains and Seas Plaque
depicts mountains, seas, sun, moon,
and the Eight Trigrams. The upper
section is approximately eight cun in
size, representing the Eight Trigrams.
The lower section is six cun and four
in size, representing the Sixty-Four
Hexagrams. The height of one chi
and two cun in height represents the
Chinese Zodiac twelve hours. The two
sides combined together and therefore
represent the twenty-four solar terms.
Such objects are often placed on the
lintel of the house to harness the power
of mountains and seas for the purpose
of feng shui. Occasionally it is also
placed in mountains, bridges, pavilions,
riversides or seaside.

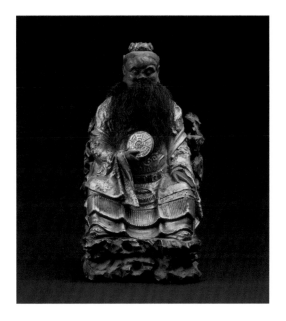

八卦祖師（伏羲氏）

材質：木
年代：待考
尺寸：12.5×22.7×10 公分

又稱伏羲大帝，古代三皇（伏羲、神農、燧人）之一。傳說伏羲創
立八卦，訂立天地萬物的準則，並教民結繩、捕魚獵獸，以鹿皮為
嫁娶之禮俗等，被尊為人文始祖，也被從事命相占卜等五術之士所
崇奉。此尊神像赤面長髯，身著金面帝袍，頭戴道冠，右手持八卦
牌，左手安放於膝上，檯座為自然的岩石造型。

Great Ancestor of the Eight Trigrams (Fuxi)

Material: Wood
Era: To be determined
Dimensions: 12.5×22.7×10 cm

Fuxi, also known as "Emperor Fuxi", is one of the Three Sovereigns (Fuxi,
Shennong, Suiren). It is said that Fuxi created the Eight Trigrams and
established principles of the universe. He taught people to knot, fish, and
hunt, and used deer skins as the etiquette of marriage rituals. Fuxi is revered
as the progenitor of human civilization and is also worshipped by practitioners
of the Five Arts of Chinese metaphysics, including fortune divination. This
statue has a red face and a long beard, and wears a gold imperial robe as
well as a Daoist crown. He holds an Eight Trigrams disc in his right hand, and
rests his left hand on his lap. The stand is in the shape of a natural rock.

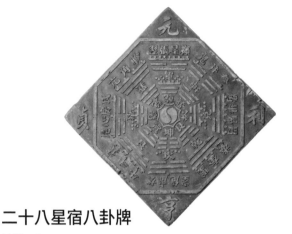

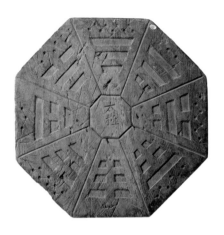

二十八星宿八卦牌

材質：木
年代：待考
尺寸：12.5╳22.7╳10 公分

八卦符號的組合，代表各種自然現象或動態，分別象徵了「天、地、雷、風、水、火、山、澤」。本牌為形制大、式樣多的八卦牌式，在先後天卦的圖式上，另在四方配以四宮二十八宿，二十八宿取自黃道、赤道旁的恆星，其後成為二十八宿神將信仰，民間相信其為星辰的靈力。故配於八卦的方位上，以增強其辟邪之力。

Eight Trigrams Plaque of Twenty-Eight Mansions

Material: Wood
Era: To be determined
Dimensions: 12.5╳22.7╳10 cm

The combination of Eight Trigrams represents various natural phenomena. Each trigram symbolizes "heaven, earth, thunder, wind, water, fire, mountain, marsh." This is a largescale Eight Trigrams plaque with various styles.

The various arrangement of the Eight Trigrams is further matched with the Four Palaces and the Twenty-Eight Mansions in the four directions.

The Twenty-Eight Mansions are derived from the fixed stars beside the ecliptic and celestial equator, which later became the belief in the deities of the Twenty-Eight Mansions. People believe they represent the spiritual power of the stars. Therefore, they are matched with the directions of the Eight Trigrams to enhance its power to ward off evil.

八卦牌

材質：木
年代：民國時期
尺寸：19╳19╳4 公分

八卦牌為民宅厭勝物中運用最廣之一類。最簡單普遍的形制由「太極」字樣與八個卦象組成。將其懸掛於民宅門楣之上，作為鎮宅辟邪之用。八卦牌除八卦圖文外，亦常搭配相對應的河圖洛書符號，以增加驅邪制煞的威力。

Eight Trigrams Plaque

Material: Wood
Era: Republic of China
Dimensions: 19╳19╳4 cm

An Eight Trigrams Plaque is one of the most widely amulets placed in houses. The simplest and most common form consists of the word "taiji" and Eight Trigrams. It is hung above door lintels for protection and warding off negative energies. In addition to the Bagua symbols, the plaques of Eight Trigrams are often paired with the corresponding symbols of Hetu (Yellow River Chart) and Luoshu (Inscription of the River Luo) to increase their power against evil forces.

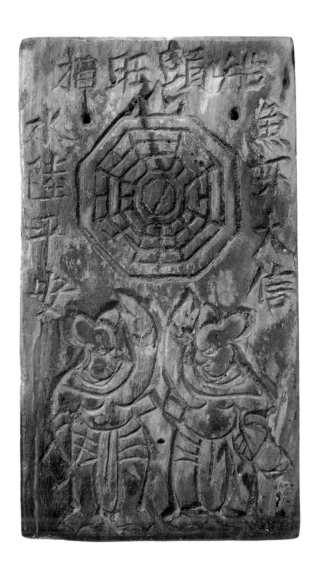

八卦牌

材質：木
年代：待考
尺寸：11.5×20×1.5 公分

中心繪有雙魚代表太極圖式，周
圍八個掛象，則代表自然界的八
種元素與力量。八卦牌除八卦圖
文外，亦常搭配其他類型的厭勝
圖文，此八卦牌為早期漁民船家
使用，上面題字「相望頭船，魚
蝦大信，水陸平安」，除了驅邪
制煞外，亦祈求漁獲豐富，航行
平安。

Eight Trigrams Plaque

Material: Wood
Era: To be determined
Dimensions: 11.5×20×1.5 cm

The central design depicts the double
fish representing the symbol of taiji. The
surrounding eight symbols represent
the eight elements and forces of nature.
This particular plaque was used by
early fishermen. The inscription refers
to blessings for abundant catches and
safe voyages

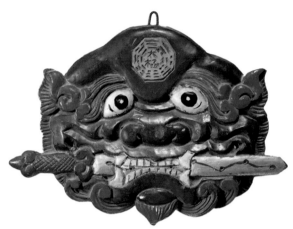

八卦劍獅

材質：木
年代：民國時期
尺寸： 21×20×2 公分

台灣民間視八卦為驅邪制煞的符號，常與其他種類的厭勝圖文搭配，藉以強化威力。此八卦劍獅牌即由八卦、獅頭、雙劍與雙蝠組成，「蝠」取其音「福」獅頭上方搭配雙蝠拱八卦，除加強安宅鎮邪的威力外，亦有祈福之意。

劍獅

材質：木
年代：待考
尺寸：26×18×2.5 公分

劍獅為民宅空間的厭勝物，獅頭造型，並於口中啣一把七星劍，頭上頂著八卦圖像，懸掛於民宅窗戶上方或門楣之上，藉以化解對屋脊或諸般沖犯所帶來的沖煞。造型特徵為寬額、凸眼、大鼻翼的人鼻、大口、鬃毛團繞。

Jianshi Sword Lion

Material: Wood
Era: To be determined
Dimensions: 26 × 18 × 2.5 cm

A sword lion is an amulet commonly placed in residential spaces. It has the shape of a lion's head, holds a seven-star sword in its mouth, and carries a Bagua image on its head. It is hung above the windows or lintels of the residential houses to ward off negative energies and protect against disturbances to the house's energy flow. It is characterized by a wide forehead, protruding eyes, a human nose with large nose wings, a large mouth, and a mane.

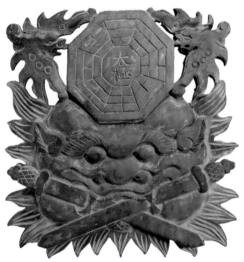

Jianshi Sword Lion with Eight Trigrams

Materia: Wood
Era: Republic of China
Dimensions: 21 × 20 × 2 cm

In Taiwanese folklore, the Eight Trigrams are seen as symbols for warding off evil spirit and subduing negative forces. They are often paired with other symbols of good luck to enforce their power. This Sword Lion with Eight Trigrams is composed of the Eight Trigrams, a lion head, two swords and two bats. The word "bat (fu)" is homophonous with "fortune (fu)" in Mandarin.
The lion's head is adorned with two bats encircling the Eight Trigrams. It serves as protection against evil and also carries auspicious blessings.

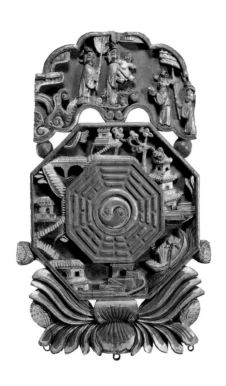

雙魚八卦牌

材質：木
年代：民國
尺寸：19×30×1.2 公分

此八卦牌中心為呈現「雙魚」形象的太極圖式，八卦周圍飾以塔、船、屋、橋等圖像以增加其辟邪功能，上下又各以「送子」與「蓮花」等吉祥題材裝飾，除了鎮宅之外並帶有濃厚的祈福意義。

Eight Trigrams Plaque with Double Fish

Material: Wood
Era: Republic of China
Dimensions: 19×30×1.2 cm

The center of the Eight Trigrams Plaque features the image of double fish formed by Taiji symbol.

The image is surrounded by towers, boats, houses, and bridges to enhance its function of warding off evil. On the top and the bottom are respectively decorated with auspicious motifs "bringing a child" and "lotus". Not only do they serve to protect the home but also carry a strong connotation of blessing.

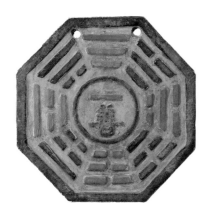

一善八卦牌

材質：木
年代：待考
尺寸：14.7×14.7×0.8 公分

將「一善」二字作為厭勝文字在台灣極為罕見。《清稗類鈔》有記載用紅束書寫「一善」二字，而將不祥之樹除去的傳說，讓「一善」二字流傳具有厭勝之力，與八卦象組成類似八卦牌的形式，更增加其辟邪制煞的功能。

Yishan Eight Trigrams Plaque

Material: Wood
Era: To be determined
Size: 14.7×14.7×0.8 cm

The use of the characters "Yi shan" as a talismanic phrase is extremely rare in Taiwan. Qingbao leichao (Categorized anthology of petty matters from the Qing Dynasty) records a legend that writing "Yi shan" on a red letter and remove an ominous tree. This practice has endowed the two characters "Yi shan" with the power to ward off evil. When combined with the Eight Trigram to form a similar object to the Eight Trigram Plaque, it further enhances its function to repel evil and subdue malevolent forces.

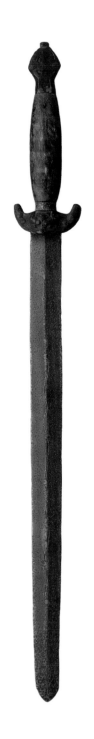

七星劍

材質：金屬
年代：待考
尺寸：5×46.2×2 公分

七星劍又稱寶劍、法劍，為斬妖
驅邪的法器，與一般刀劍相異之
處，在其劍身嵌有七顆鈕釘以固
夾鋼，以此象徵北斗七星，藉其
威力以驅除邪精；為傳說中道教
張天師所用法器之一；有時劍身
也飾以符文，增強其靈力。為道
士隨身護身，並在壇上用以召喚
四靈的法器。

Seven-Star Sword

Material: Metal
Era: To be determined
Dimensions: 5×46.2×2 cm

The Seven-Star Sword, also known as
the Treasure Sword or Ritual Sword, is
a ritual implement used to slay demons
and dispel evil. Unlike ordinary swords,
it has even studs which symbolize the
Big Dipper embedded in its blade
to harness its power to banish evil
spirits. It is said to be one of the ritual
implements used by Daoist Celestial
Master Zhang Tianshi. Sometimes the
sword is also adorned with talismanic
scripts to enhance its spiritual power.
Daoist priests carry the Seven-Star
Swords as a personal protective charm
and also used the Swords on the altar
to summon the four spirits.

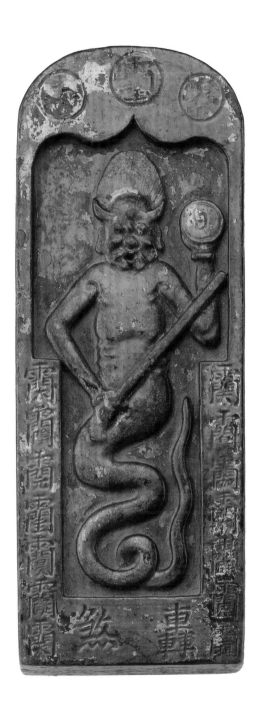

五雷令牌

材質：木
年代：待考
尺寸：7×18.5×3.7 公分

五雷令牌或稱雷令或五雷牌，為重要的木製道壇法器之一。高功道士行科演法時，持以役使雷神護衛道壇並驅逐邪崇。其形上圓下方以象天地。令牌正面為天皇大帝，袖左手托日精，右手持長劍，蓬頭長角，怒目獠牙，似憤怒樣貌。左右並分別刻有道教諱字，所謂諱字為道教神仙譜系中的天神代號。

Five Thunder Tablet to Command Spirits

Material: Wood
Era: To be determined
Dimensions: 7×18×3.7 cm

The Five Thunder Tablet to Command Spirits Is also known as Thunder Tablet or Five Thunder Tablet. It is an important wooden ritual implement for Daoist altars. High-ranking Daoist priests use them during rituals to command the Thunder Gods to guard the altar and expel malevolent spirits. Its shape, round above and square below, symbolizes heaven and earth. On the front of the tablet is the Jade Emperor. He has the essence of the sun in his left hand and a long sword in his right hand. His hair is disheveled with long horns. With fierce eyes and fangs, the Jade Emperor appears angry. On his left and right sides are inscribed Daoist taboo characters, which are codenames for deities in the Daoist pantheon.

亞伯拉罕信仰

Abrahamic Faiths

亞伯拉罕信仰認為，天地萬物是造物主賜予人類的恩賜，人類是造物者的「代治者」。在猶太教中，羊角號被用來宣告重要時刻，提醒人們尊重時間與自然的節奏；安息日油燈則象徵安息與重建的必要性。猶太聖典中也規定了保護環境的責任，《創世紀》和《詩篇》提及人類被賦予管理和保護萬物的使命。

伊斯蘭教強調愛護自然，主張合理開發利用自然資源，以造福人群。人類必須善待動植物，找到與他們的平衡關係。用水器具在清洗和禮拜中被廣泛使用，象徵著純潔和對自然資源的節制。這些符號和實踐都彰顯了亞伯拉罕三教中對自然的敬畏、感激與和諧共處的價值觀。

The Abrahamic faiths believe that the universe and all things are gifts from the Creator to humanity, and humans are the "stewards" of the Creator. In Judaism, the shofar is used to announce significant moments to remind people to respect time and the rhythm of nature; the Sabbath oil lamps symbolize the necessity for rest and renewal. The Jewish scriptures also mandate the responsibility to protect the environment. The Book of Genesis and the Psalms mention the mission entrusted to humanity to manage and safeguard all creation.

Islam emphasizes the care for nature and advocates for the reasonable development and utilization of natural resources for the benefit of the community. Humans must treat flora and fauna kindly and find a balanced relationship with them. Water vessels are widely used in cleansing and worship and symbolize purity and restraint in the use of natural resources. These symbols and practices highlight the values of reverence, gratitude, and harmonious coexistence with nature shared among the Abrahamic religions.

安息日油燈

材質：白鑞
年代：西元1820年
尺寸：直徑32.5 公分

安息日油燈，是猶太傳統中用於
標誌安息日開始的重要器物。這
種油燈在週五日落前點燃，持續
照明至週六晚上，象徵著上帝創
造世界時的第一道光。燈火提醒
人們上帝在六天內創造世界後的
安息，也是對自然循環的敬畏的
表達。

Sabbath Oil Lamp

Material: Pewter
Era: 1820 CE
Dimensions: diameter 32.5 cm

In Jewish tradition, the Sabbath oil lamp
is an important object used to mark the
beginning of the Sabbath. Lit before
sunset on Friday, it remains illuminated
until Saturday night and symbolizes the
first light when God created the world.
The light reminds of God's rest after six
days of creation and shows the awe for
the natural cycle.

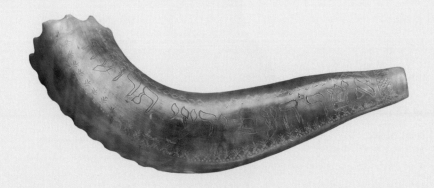

羊角號

材質：羊角
年代：西元1900年
尺寸：13.2×26.3×3.6 公分

羊角號是由潔淨的動物——公羊
的角所製成。羊角號聲於新年和
贖罪日時吹起，敦促族人自我反
省，並懇求上帝仁慈的審判。羊
角號聲還在週五下午響起以宣布
安息日的開始。羊角號上雕刻的
希伯來文為「知道羊角號聲的人
們」。

Shofar (Horn)

Material: Ram's horn
Era: 1900 CE
Dimensions: 13.2×26.3×3.6 cm

The Shofar is made from the horn of
a clean animal, specifically a ram.
The sound of the Shofar is blown on
New Year and Yom Kippur, urging
the community to self-reflect and
seek God's merciful judgment. The
Shofar sound is also heard on Friday
afternoon to announce the beginning
of the Sabbath. The Hebrew inscription
on the Shofar reads "The people who
know the sound of the Shofar."

水壺

材質：陶
年代：西元二十世紀
尺寸：16.8 × 42 × 16.8 公分

水杯

材質：金屬
年代：西元二十世紀
尺寸：11.1 × 4.9 × 11.1 公分

朝覲為伊斯蘭教義中的「五功」之一。凡是來到麥加朝覲的人，都能看到沙漠山谷中出現的滲滲泉水。根據傳說，泉水是由天使加百列奇蹟般為先知易卜拉欣的兒子伊斯瑪儀湧出的，穆斯林認為這泉水獲得了真主的祝福，具有滿足飢渴和治療疾病的神奇效能，常將此裝於朝聖用水壺，帶回家鄉，作為祝福和醫療之用。

水杯則是十九世紀末麥加人用來從滲滲泉取水的傳統器具，此井由當地的管理組織維護，成為禁寺中的公共設施。隨著現代化進程，傳統取水方式被水龍頭取代，這種水杯逐漸演變為具有紀念價值和地方特色的工藝品。

Water Jugs

Material: Pottery
Era: 20th century CE
Dimensions: 16.8 × 42 × 16.8 cm

Drinking Cup

Material: Metal
Era: 20th century CE
Dimensions: 11.1 × 4.9 × 11.1 cm

Hajj is one of the "five pillars" of Islam doctrine. Those who come to Mecca for pilgrimage can see the Zamzam spring water seeping in the desert valley. According to legend, the spring water miraculously gushes out for Ismail, the son of Prophet Ibrahim, by the angel Gabriel. Muslims believe that this spring water has been blessed by Allah and has the miraculous effect of satisfying hunger and thirst and curing diseases. It is often carried back home in pilgrimage water jugs as a blessing and for medicinal purposes.

The water cup is a traditional utensil used by Meccans to draw water from the Zamzam Well at the end of the 19th century. This well is maintained by the local management organization and has become a public facility in the Masjid al-Haram. With the process of modernization, the traditional way of drawing water was replaced by the faucet, and this water cup gradually evolved into crafts with commemorative value and local characteristics.

古蘭經

材質：紙
年代：西元1730年
尺寸：32×21×5 cm

「古蘭」一詞源於阿拉伯語al-Qur'ān的音譯，為「朗誦」或「讀本」之意。古蘭經為真主安拉啟示的集結，共三十卷，一一四章，各有不同主題，為伊斯蘭教教義和信仰的主要依據。本手抄經書為十八世紀回教蒙兀兒皇室所使用，全文由右至左，橫式書寫，開卷對頁以金色繁複圖案與艷麗色彩裝飾，隨後經文則以金框圈飾。

Foundation of Islamic teachings

Material: Paper
Era: 1730 CE
Dimensions: 32×1×5 cm

The word "Quran" is derived from the transliteration of the Arabic al-Qur'an, which means "recitation" or "reading book". The Quran is a collection of revelations from Allah, consisting of thirty volumes and one hundred and fourteen chapters, each with a different theme, and is the main basis for Islamic teachings and beliefs. This handwritten scripture was used by the Muslim Mughal royal family in the 18th century. The entire text is written horizontally from right to left. The opening pages are decorated with complex golden patterns and bright colors, and the subsequent scriptures are decorated with gold frames.

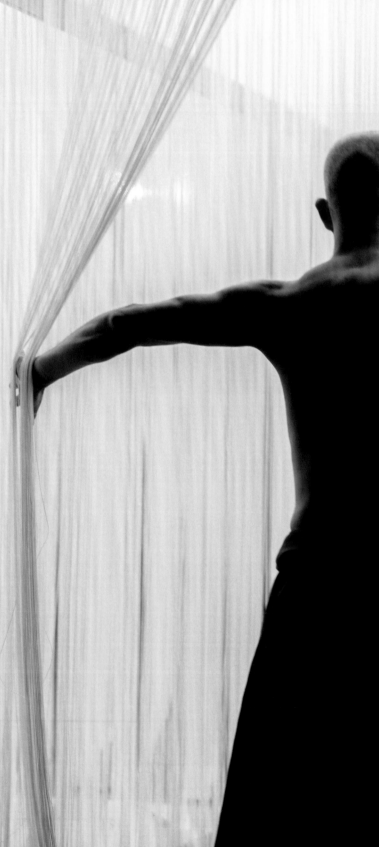

人們終將回歸自然

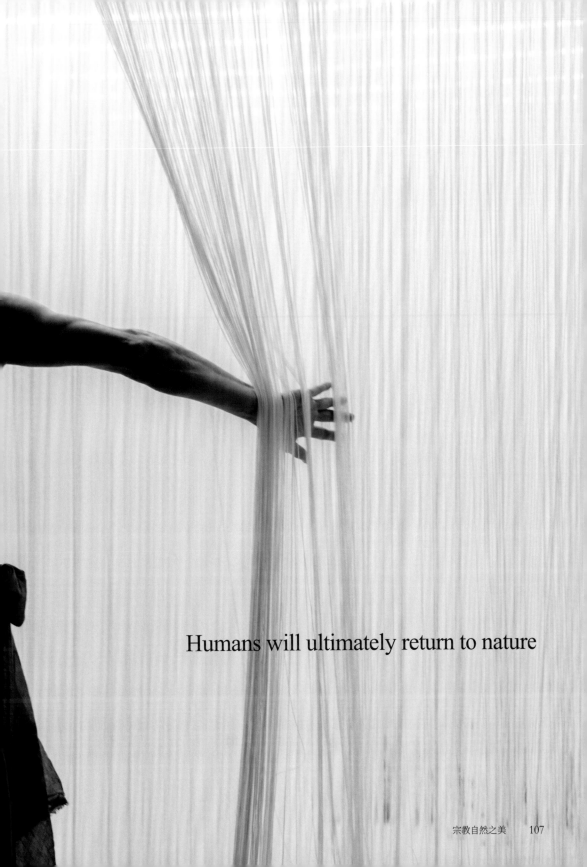

Humans will ultimately return to nature

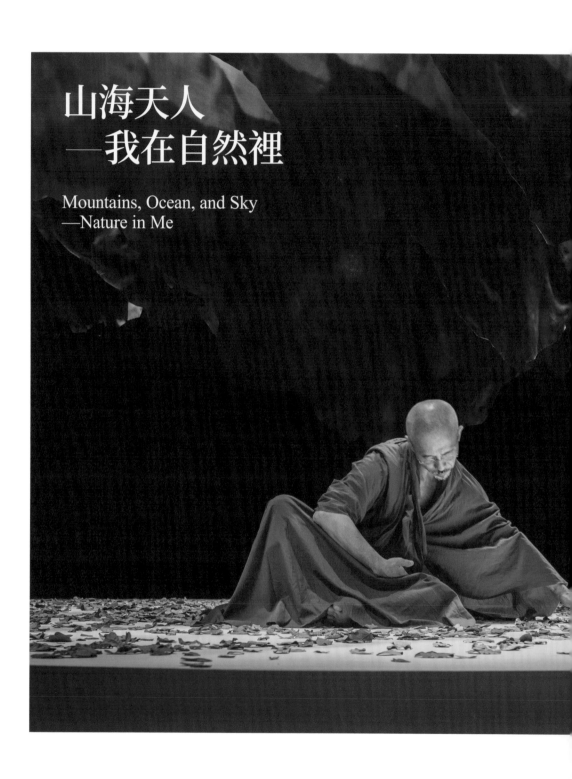

山海天人
—我在自然裡

Mountains, Ocean, and Sky
—Nature in Me

" 歲月之於蝴蝶，不以月計，僅須臾片刻，
　卻已然足夠。"

——泰戈爾

當被放在山的環抱，海的洶湧，天的遼闊，人是怎樣的存在？

張開所有的感官感受，知覺，探索，這天大地大對人來說是怎樣的存在？

把山與海與天那個外面不知多麼大的世界，塞進展場，那全然是另一種將人放入大自然的方式。看山，不只可以仰望。聽海，不只隨波逐流。而那片天，不只白天黑夜。

透過這個奇幻也似的超現實展場，不同以往的角度進入山海天地之間，隨心所之開啟的內心對話：不論寧靜，不論爽快，不論澎湃，不論迷眩，就是那個屬於「我」與自然的脈動。我在自然裡，自然也進入我否？我在一切，一切在我。

" The butterfly counts not months but moments,
　and has time enough. "

——Rabindranath Tagore

When embraced by high mountains, wavy oceans and vast sky, what does human existence mean?With all senses fully awakened for perception and exploration, how does this immense world manifest itself to an individual?

Bringing the immense world, encompassing mountains, oceans, and the sky, into an exhibition, we attempt to immerse humans in nature. Extending our observation of mountains beyond mere upward gazes; listening to the oceans instead of drifting with the currents, we find that the expansive sky holds more than the alternation of day and night.
Through this enchanting and surreal exhibition, we venture into the realm encompassing mountains, seas, and sky, and approach it from a unique standpoint, thereby initiating an internal dialogue driven by our own aspirations. Whether in moments of tranquility or exhilaration, or being overwhelmed or mesmerized, it is the rhythm that resonates within the bond between "me" and nature.
Am I immersed within nature, or does nature permeate my being? I exist within all things, and all things exist within me.

❝你不僅是潮浪，你是海洋的一部分。❞

——米奇·艾爾邦

潮來潮往不曾停歇，當海水化為泡沫浸潤全身細胞，開啟感觀
最直接的覺知：
週而復始反復沖刷的回憶是什麼？
沙灘上的稍縱即逝又是什麼難以忘懷？
凝視海浪，穿透這不止息的能量，洋流湧著秋千蕩漾，那是緊
貼著肌膚的溫度呢！
海洋浩瀚，我在其中。

❝You're not a wave, you're part of the ocean.❞

—— Mitch Albom

The ebb and flow of the tides never cease, as the sea water transforms into bubbles,
permeating every cell of the body and awakening the most immediate senses:
What are the memories that repeatedly wash over us? What are the most unforgettable
flashes of time on the beach?
Gazing through the unending energy in the ocean waves, swinging with it like a
pendulum, and feeling the caress over skin, I am part of the ocean.

THE BEAUTY OF NATURE IN RELIGIONS

宗教自然之美

創辦人｜釋心道

發行人｜釋顯月

主編｜馬幼娟

執行編輯｜陳昱瑋、王彥麒

美術編輯｜張士勇

翻譯｜王韻寧

攝影｜邱德興

感謝照片提供｜靈鷲山資料中心、杜岳軒

出版｜世界宗教博物館

新北市永和區中山路一段236號7樓

電話｜（02）8231-6118

www.mwr.org.tw

ISBN｜978-986-97431-9-8

初版一刷｜2024年7月

定價｜新台幣700元

版權所有翻印必究

Printed in Taiwan